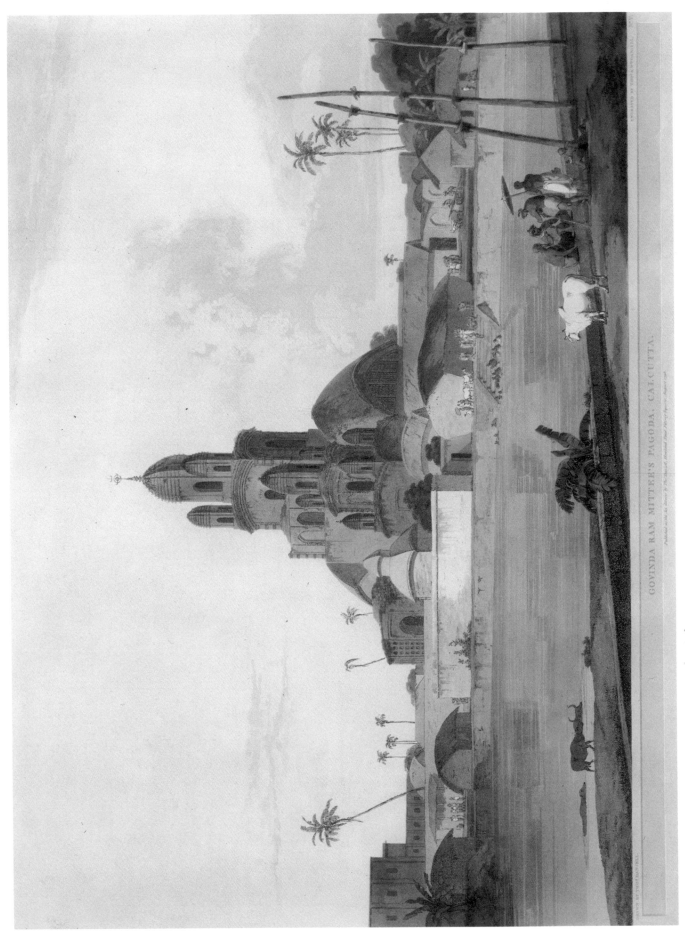

T. & W. Daniell, *Govinda Ram Mittee's Pagoda, Calcutta*, cat. 11

A JOURNEY TO HINDOOSTAN

GRAPHIC ART OF BRITISH INDIA

1780-1860

Catalogue and Exhibition by
Thomas P. Bruhn

Essay by
Mildred Archer

Prints from the Max Allen & Peter Allen Collection

THE WILLIAM BENTON MUSEUM OF ART
THE UNIVERSITY OF CONNECTICUT, STORRS

Exhibition Schedule:

The William Benton Museum of Art
Storrs, CT
March 23–May 22, 1987

Sterling and Francine Clark Art Institute
Williamstown, MA
June 20–September 13, 1987

Copyright © 1987 by The University of Connecticut
Published by The William Benton Museum of Art

Library of Congress Cataloging-in-Publication Data

Bruhn, Thomas P.
 A journey to Hindoostan.

 Bibliography: p.
 Includes index.
 1. Prints, British—Exhibitions. 2. Prints—18th
century—Great Britain—Exhibitions. 3. Prints—19th
century—Great Britain—Exhibitions. 4. Allen, Max,
1924- —Art collections—Exhibitions. 5. Allen,
Peter, 1951- —Art collections—Exhibitions.
6. Prints—Private collections—United States—
Exhibitions. 7. India in art—Exhibitions. I. Archer,
Mildred. II. William Benton Museum of Art. III. Title.
NE628.2.B78 1987 769'.49954031 87-6128
ISBN 0-918386-37-3 (pbk.)

Printed by Thames Printing Co., Inc., Norwich, CT

One of the great constants of human feeling is to tell people who live sedentary lives at home of your travels. This instinct was greatly indulged in in the eighteenth and early nineteenth centuries by Britishers going to India. This, perhaps fortunately, was before the age of the camera. Accordingly, the desire to inform had to be realized through sketches, paintings, and prints. These gave a diversely interesting view of India to those otherwise denied the reality. And from this material comes this superb exhibit. It is from the collection of Max Allen, the diligent chairman of the New England chapter of the great Indian cultural organization the Bharatiya Vidya Bhavan. I am delighted to add my warmest recommendation to this exhibition at The University of Connecticut and, subsequently, at the Sterling and Francine Clark Art Institute in Williamstown. No one who views these pieces will, I think, be disappointed.

JOHN KENNETH GALBRAITH

INTRODUCTION AND ACKNOWLEDGMENTS

As Professor Galbraith suggests, the period from the late eighteenth to the mid-nineteenth centuries was a time when India came forcefully to the mind and eye of the British, and with this increasing interest a new body of topographical and ethnographical literature arose. The masterpieces of this visual and literary endeavor are the great prints, illustrated portfolios, and colored books that the British professional and amateur artists produced at this time. The exhibition *A Journey to Hindoostan* is a cross-section of these prints and books and offers a history and study of them, of the artists who created them, and of the British aesthetic sensibility that explored this exotic land. While in the past several years the colored prints and books of British India have received some attention, most notably in the catalogue of the Victoria and Albert Museum, *India Observed* (London, 1982), the prevailing approach has been to treat them as adjuncts to a larger theme, as in the Pierpont Morgan Library's exhibition *From Merchants to Emperors* (New York, 1986). In *A Journey to Hindoostan* the prints and books are the sole focus of the exhibition and catalogue.

The catalogue is a collaborative effort between Dr. Mildred Archer, Mr. Max Allen, and me. Dr. Archer, who is the foremost British scholar of this period and responsible for a major share of modern scholarship on the subject, has contributed the introductory essay, in which she explores the thematic history of the books and prints of British India. Max Allen, the passionate

collector of these objects, is past Honorary Consul of India in Boston and present Chairman of the New England chapter of the Bharatiya Vidya Bhavan. The latter body is an all-India cultural and educational organization, which, with its educational centers and schools of higher learning, has become a national and international symbol of the intellectual and cultural life of India from past to present. Many of the donors who have helped to underwrite this catalogue are affiliated with the Bhavan and have contributed in its name. Contributions have come from Mr. and Mrs. Lionel Borkan; Data Conversion, Inc.; Hon. Paul W. Garber, Consul of Chile in Boston; Hon. Philip C. Garber, Consul of Chile in Boston; Mr. Amol Golikeri; Mr. and Mrs. Anand D. Golikeri; Mr. Vivek Anand Golikeri; Hobhouse Ltd., London; Navin Kumar, Inc.; Mr. and Mrs. Narendra K. Patni; Mr. and Mrs. Mahesh Sharma; Mr. and Mrs. Herbert L. Shivek; and Mr. and Mrs. John J. Travaglini. The Benton Museum is deeply grateful to them.

The section of the catalogue that treats of the individual artists and works in the exhibition is my responsibility. While I have benefited greatly from the comments of Max Allen and have clearly depended upon the scholarship of Dr. Archer, whatever faults are present are solely my own.

Any number of people have contributed to the making of this exhibition. Among those we are most grateful to is Lasse Antonsen of the Danforth Museum,

who first brought the Allen Collection to our attention. Because of the interest of David Brooke, Director, and Rafael Fernandez, Curator of Prints and Drawings, of the Sterling and Francine Clark Art Institute, the exhibition will be on view at the Clark Art Institute in the summer of 1987. Richard Schimmelpfeng, Head of Special Collections, Homer Babbidge Library, The University of Connecticut, kindly agreed to lend the first edition of George Atkinson's *Curry & Rice*. Much of the work I have done was possible only through the help and generosity of two libraries. One is the Print Room of The New York Public Library under Roberta Waddell. The other is the Rare Book Room under Joan Friedman at the Yale Center for British Art, Yale University, where much of John Abbey's Indian collection is located. Finally, I would like to thank the staff of The William Benton Museum of Art, and particularly Hildegard Cummings, who edited this catalogue, for their help and support.

DR. THOMAS P. BRUHN
Curator, Art Collections

INDIA AND THE ILLUSTRATED BOOK

The illustrated book is not perhaps absolutely necessary to Man's life but it gives such endless pleasure... that it must remain one of the very worthiest things towards the production of which reasonable man should strive.

WILLIAM MORRIS

The Illustrated Book

In the late eighteenth and early nineteenth centuries India provided rich and varied subject matter for some of the finest illustrated books ever published in England. The prints in these books depicted the countryside of India, its monuments, its people, the main cities where the British were concentrated, and certain historical events in which the British were involved. They were executed in a variety of techniques, but many of the finest were in aquatint, a process invented around 1768 and so complicated a medium that it has been described as "an art invented for the torment of man."

Aquatint is an etching process that is tonal rather than linear. An acid-resistant resin is sprinkled onto or dissolved on a copper plate to form a porous ground. When the plate is placed in an acid bath, the acid bites into the copper between the resin grains and creates a pattern of tiny etched dots. If printed at this stage, the plate would print a uniform gray tone, but an etcher achieves tonal gradations by "stopping out" some elements of a design with acid-resistant varnishes and deepening the "bite" of others with successive acid baths. In conjunction with an etched line to give form, the aquatint process can produce an excellent imitation of watercolor painting, and thus it soon became associated with the depiction of landscape.

In the early nineteenth century aquatint gradually gave way to lithography, a quicker and easier technique of printmaking invented in 1798, which amateurs themselves could often master. Lithography involves no etching. Drawings are made on a thick slab of polished limestone with a special ink or greasy crayon. The surface is then sponged with water, and when printing ink is applied, the ink adheres to the greasy drawing but not to the damp surface. A lithography press transfers the inked image to paper. A later development was chromo- or color lithography, patented in 1837, but this process was little used before the middle of the century. Line etching, aquatint, and lithography are all represented in this exhibition. The prints were most often colored by hand.

The passion for fine illustrated books that developed in England in the late eighteenth century and continued until about 1860 gratified the British public's lively interest in 'The Picturesque' and 'The Sublime.' The enjoyment of natural scenery was one of the principal leisure occupations of the more cultured members of the British public and was considered an important part of cultivated life. This largely explains the spate of fine books on India that were published in the period, for India was adding a new dimension to the appreciation of landscape. Outstanding among such books were *Select Views in India*, 1785–88, by William Hodges (1744–1797) and *Oriental Scenery*, 1795–1808, by Thomas Daniell (1749–1840) and William Daniell (1769–1837). The 144 aquatints in *Oriental Scenery* were etched by the Daniells themselves, and all but 24 were after their own designs. Most amateurs, however, depended upon professional engravers in England for translating their watercolor sketches into aquatint or lithography. Outstanding for etching and aquatinting was the family firm of Robert Havell in London, which was used by James Baillie Fraser (1783–1856) for producing his superb *Views in the Himala Mountains*, 1820, and *Views of Calcutta and Its Environs*, 1824–26. In making these prints, the Havells were clearly emulating *Oriental Scenery* in both size and subject matter.

Most of the aquatints in this exhibition were made by professional printmakers who had never been to India, after watercolors by skilled British amateurs working there in their leisure time. The high standard of amateur drawing in India in the late eighteenth and early nineteenth centuries was largely owing to the education British men and women had received in England. British army engineers and gunners learned military and architectural drawing at the Royal Military Academy, Woolwich, while officers were instructed at the Military College, High Wycombe. When the College moved to Sandhurst, instruction continued on the same lines. The East India Company's military officers were trained at the Military College, Great Marlow, and later at Addiscombe, while its civil servants were educated at

Haileybury College, where several well-known artists were employed as drawing masters. This excellent training explains the high quality of the drawings made by so many British men in India. Women, too, often received excellent instruction as part of their general education at home before going out to India, and a number of publications included illustrations after drawings by women.

The great illustrated books of this period record a happy moment when a special sensitivity to landscape, architecture, and the human race found expression in England. Complete volumes of these books are very rare today. When prints were bound into them, they had to be inserted sideways, and there is no doubt that this awkward format, which was difficult to shelve, largely explains why complete folios can now seldom be found. Most volumes have been broken up over the years and the prints framed or singly preserved. It is fortunate, therefore, that a number of complete folios can be seen in the present exhibition. At the same time, individual prints can be appreciated.

Calcutta, Madras, and Bombay

Not surprisingly, some of the earliest aquatints of India depict the two principal cities of Calcutta and Madras, for the British had founded these cities and took great pride in them, especially Calcutta. That city was the subject of the first publication that Thomas Daniell made soon after he and his nephew William arrived in India in 1786. In *Views in Calcutta*, 1786–88, Thomas experimented for the first time with the new medium of aquatint, and not too successfully. Thomas and William later judged their technique here to be amateurish compared with that of their subsequent work.

In this set of 12 views Daniell depicted a city that was thriving politically and commercially and growing rapidly. A new fort had been built in 1757, and the open area around it, originally intended for firing space, was now a peaceful grassy expanse where the city's inhabitants could stroll in the evening "to eat the air." In the 1780s the British residential area was developing at a great rate. Fine Palladian houses were being built along the two main streets of the city, Chowringhee and Esplanade Row, where Government House and the Council House were situated. Writer's Building, where the young civil servants were housed, had been built in 1780, and in 1784 there was a new Court House at the end of Esplanade Row. The docks and the approaches to the river were also being improved. Thomas Daniell made numerous drawings of the city, which included all the important buildings he thought would interest the British who lived there or who had relatives in the city. These views included the Old Fort, the New Court House, and Tank Square (fig. 1), which was the fashionable center of Calcutta, with its elegant railings and imposing gateposts. Along the river bank were the steps or *ghats* (fig. 3) down to the River Hooghly, which was crowded with shipping of various kinds. Daniell depicted all these areas in *Views*. The city was far from fully developed: many of the roads were rough and still unpaved, and there were as yet few trees, gardens, or grassy public squares, but in *Views in Calcutta* we can sense that the fine classical architecture of the main buildings already reflected the growing pride of the new settlers from England and their belief in the future of the city (fig. 2), while the smart carriages and palanquins in the streets bore witness to their comfortable way of life.

During the next three years, from 1788 to 1791, the Daniells traveled around upper India. By the time they returned to Calcutta late in 1791, more buildings had been erected. They made drawings of the city that included a few picturesque Indian buildings: Govinda Ram Mittee's Pagoda (frontispiece) and Indian shops and houses in the Chitpore Road (fig. 4). These later views of Calcutta were included in their great publication, *Oriental Scenery*, etched after their return to England in 1794 and issued in six parts between 1795 and 1808.

The next phase of Calcutta's development was recorded between 1815 and 1817 by James Baillie Fraser (1783–1856), a Scottish merchant working in the city with the firm of Mackintosh. Fraser was an enthusiastic amateur artist. While traveling in the Himalayas with his brother William in 1815, he developed a keen desire to draw and paint the superb scenery, and he made many sketches. Back in Calcutta he was fortunate in meeting two professional British artists, George Chinnery and William Havell, who were willing to instruct him in drawing. Excited by his own rapid improvement, he decided to make finished watercolors of the city to which he was so much attached. After his return to England, 24 of them were engraved by the firm of Robert Havell and published in 1824–26 as *Views of Calcutta and Its Environs*. They depict the city as it was about twenty years after the Daniells' sojourn there, and they show its development. Many new buildings appear, above all the imposing new Government House, which had been built by Marquis Wellesley in 1799–1802. It was based on Kedleston Hall in Derbyshire and was a most elegant building, with a fine colonnade of classical columns supporting a huge pediment. Impressive entrance gates stood on all sides. A town hall and fine churches with imposing porticos had also been built since the Daniells' time, and many great mansions had been erected along Esplanade Row. Along the river a new thoroughfare, Strand Road, had been laid out, where the British could enjoy the evening air and drive in their carriages. This gave superb views across the river,

busy with picturesque Indian craft and great East Indiamen lying at anchor.

Fraser drew a temple in the old city (fig. 9), as well as the busy *ghats*, where cargoes were unloaded (fig. 5). His views show how the old mercantile city had become an imposing provincial capital. In particular, Fraser's drawing of one of the great gates of Government House reflects the new mood (as does the depiction by D'Oyly, fig. 10). Its huge form dominates the scene. It becomes a symbol of grandeur—a great triumphal arch that might almost have come from Rome. Fraser's pride in the city is only too obvious in all his drawings. Yet at the same time his scenes reveal his romantic delight in the Indian aspects of the city, with its great river, its mud huts, its temples, and its streets crowded with colorful throngs and diverse types of transport.

Fraser's feelings for the city are perhaps best symbolized by his aquatint, *A View of the Botanic Garden House and Reach* (fig. 6). The Garden had been founded in 1786 and was a popular place for an evening stroll. The beauty of the river, with its line of comfortable white mansions on the far bank, must have tempted Fraser to settle permanently in India, but the proud East Indiamen sailing by offered an easy means of escape from the East to his homeland. The temptation to stay was clearly strong, but his business affairs were worrying, and in the end Fraser had to return to Scotland and supervise from there the engraving of his drawings by the London firm of Havell, run by relatives of one of the artists from whom he had learned so much.

Further views of the city were made a few years later by Sir Charles D'Oyly (1781–1845), an East India Company servant who arrived in India in 1797. In Calcutta until 1808, first as Assistant to the Magistrate of the Court of Appeal and then as Keeper of the Records to the Governor-General's Office, he lived there again from 1818 until 1821, when he was Collector of Government Customs and Town Duties. He was a skilled amateur artist, working mainly in watercolor. During his second stay in Calcutta, he studied art with Chinnery, as Fraser had. Like Fraser, too, he took great pride in the city and its architecture, and he made drawings of many of the main buildings. He also loved the Indian suburbs: in the cool of the evening he would drive or ride out and sketch picturesque scenes—the canal called Tolly's Nulla on the southern edge of the city (fig. 12), a small Hindu temple near the Strand Road, a little mosque at Borranypore (fig. 11), or villages surrounded by graceful palm trees and spreading banyans. D'Oyly's drawings were not published until 1848, three years after his death, but they record the city as it was during the years 1818 to 1821.

Numerous amateur artists were inspired by the great river Ganges. They painted it in all its phases—calm and peaceful in the cold weather—or swollen and dangerous, breaking its banks in the rains, as Captain Thomas Williamson (1758–1817) depicted it (fig. 13).

Madras was much smaller than Calcutta and had fewer grand buildings. Thomas and William Daniell soon realized, however, that the city was of great topical interest to British families in England, as it was the base from which the Mysore Wars of 1767–99 were being waged against Tipu Sultan, "The Tiger of Mysore." A great many British troops who were involved in these operations landed at Madras and came to know the city well. The Daniells, therefore, went south to Madras in March, 1792, and made drawings of the city that were later included in their *Oriental Scenery*: the Armenian Bridge, Black Town, the Assembly Rooms and Race Course (fig. 14), and *A South East view of Fort St. George* (fig. 15). The latter shows surf breaking on the shore, the great East Indiamen anchored in the Roads, and boats bringing passengers ashore. In the distance is Fort St. George, the Exchange, and the Church of St. Mary. More views of Madras were made by Colonel Swain Ward (1734–1794), and these, along with others by the Daniells, were etched and published by William Orme as *24 Views in Hindostan*. This portfolio was usually published with Francis William Blagdon's *A Brief History of Ancient and Modern India*, 1805. The etchings were based largely on oil paintings by Ward and the Daniells that had been purchased by Richard Chase when he was mayor of Madras.

The difficulty of landing and embarking at Madras was legendary. Because the surf was so heavy and dangerous, ships regularly had to anchor out to sea, and passengers were brought to shore in tiny *masula* boats and assisted onto dry land. It was a favorite pastime for young army officers to go down to the beach and help carry passengers to land—especially young ladies, as there was a good chance of seeing ankles and legs. Two amusing aquatints of these scenes by G.B. East (active 1837) proved extremely popular (figs. 17, 18).

Bombay had been acquired by the Crown as early as 1661, but it received far less attention from artists than Calcutta or Madras. It was not until the opening of the Suez Canal in 1862 that Bombay became a great port and overshadowed Madras. As a result there are few pictures of Bombay during the early period. The first engravings to depict the city were published by Captain Robert Grindlay (1786–1877) in *Scenery, Costumes and Architecture, chiefly on the Western Side of India*, 1826–30, and by J. M. Gonsalves in his *Views at Bombay*, c.1831. The latter recorded the main public buildings: Government House, the Town Hall, the New Mint, and St. Thomas's Church.

The Picturesque and The Sublime

Of wider significance, however, than the depiction of the cities of Calcutta, Madras, and Bombay were the illustrations that resulted from the gradual exploration of India by the British and the recording of the Indian scene in painting, as British administration gradually spread over India. The varied countryside, ranging from flat plains and great rivers to the snow-capped Himalayas, provided superb subjects to suit the contemporary vogue for 'The Picturesque' and 'The Sublime.' William Hodges was the first British artist to depict India and to make a significant contribution in this field with his *Select Views in India*, published in 1786–88. On arriving in India in 1780 he was already an experienced traveler and landscape painter. As a young man he had been apprenticed to the painter Richard Wilson. In 1772 he had accompanied Captain James Cook on his second voyage to the Pacific. Through contact with sailors and scientists he had come to look keenly at landscape and had become extremely sensitive to effects of light and atmosphere and to strange new forms. This led to a highly individual and novel style, which showed itself in his views of the South Seas. After the death of his wife in 1777, he decided to visit India.

On reaching Madras in 1780 he found that the Second Mysore War of 1780–84 was in progress in that region, so that it was impossible for him to tour widely there. He moved, therefore, to Calcutta in February, 1781, where he was welcomed by the cultured Governor-General, Warren Hastings. His first year there, Hodges made two tours in Upper India with Hastings and met Augustus Cleveland, a brilliant, cultivated young administrator stationed at Bhagalpur in Bihar, who had a consuming interest in the Paharias, a primitive tribal people living in his district. Hodges toured with him and made the first known drawing of a Paharia village (fig. 19). He also visited Rajmahal, the former capital of Bengal and Bihar (fig. 20). In May, 1783, he made a long tour upcountry with a Major Brown, who was leading a diplomatic visit to the Mughal Court. Hodges was thus able to see novel forms of architecture that greatly attracted him. He visited and recorded some of the great Mughal monuments at Delhi, Agra, and Sikandra (fig. 21) and then returned to Calcutta by way of Lucknow. On his return to England he published *Select Views in India*, 1785–88, with 48 aquatints based on the sensitive drawings he had made between 1781 and 1783. Both Hodges' subject matter and style were entirely novel, and from these etchings the British public gained its first extensive view of Indian architecture and the Indian countryside.

There is no doubt that Thomas Daniell was somewhat irked by the appearance of Hodges' *Select Views*. He had come to India in 1786 and felt that Hodges had forestalled him. In August, 1788, therefore, as soon as the rains had slackened, he and his nephew William set off from Calcutta on an ambitious tour upcountry. They journeyed first up the Ganges by riverboat from Calcutta to Cawnpore, going ashore en route at every place where they could encounter picturesque scenery or interesting architecture. At Bhagalpur they stayed with the local magistrate, Samuel Davis, who advised them on their tour. They halted at Patna, Benares (fig. 22), and Allahabad. At Cawnpore they joined a party of military officers with whom they traveled overland to Agra, Sikandra (fig. 23), and Delhi. The hot weather was now beginning, so they decided to make a detour up into the Himalayan Mountains. They were the first Europeans to reach Srinagar in Garhwal and draw the fine mountain scenery. In May, 1789, they descended again to the Plains and returned by boat down the Ganges as far as Benares. From there they made a detour overland to the great Mughal fort of Rohtasgarh near Sasaram. They visited the Barabar Caves at Gaya and then made their way back to Bhagalpur to stay once more with Davis. With him they visited the ruins of the ancient city of Gaur before returning to Calcutta in November, 1791.

After raising money there from a lottery of their paintings, they went south to Madras in March, 1792. The Mysore Wars were still in progress but, undeterred, the Daniells now made an adventurous tour, visiting many of the great hill-forts (*droogs*) where fighting had recently been taking place, such as Hosur, Verapadrug, Sankridrug, and Raikottai. They found superb subjects everywhere, which they knew would appeal to the fashionable taste for the Picturesque and the Sublime. They drew the great rocky hills crowned with forts (fig. 24), they visited the huge waterfall of Papanasam (fig. 25), magnificent temples such as that at Mahabalipuram (fig. 26), and the palace at Madurai. They even reached the southernmost point of India at Cape Comorin (fig. 27). Loaded with drawings they returned to Madras in February, 1793, and held another lottery.

On the proceeds of it the Daniells set off for Bombay in February, 1793. Here they met the artist, James Wales (1747–1795), who had been quietly working there since 1791, painting pictures of the rock-cut temples. He showed them the great caves of Elephanta (fig. 28), Karle, and Kanheri, as well as a number of small, lesser-known caves on Salsette Island. They stayed until May and were forced to return to England by way of China, as war had broken out between the French and the British. Back in England in September, 1794, the Daniells at once worked up some of their hundreds of drawings into aquatints, publishing 144 of them in six parts, between 1795–1808, as *Oriental Scenery*. The sixth part, *Hindoo Excavations in the Mountain of Ellora*, was based on James Wales' drawings (fig. 29),

forming a supplement to the fifth part, *Antiquities of India*, which also contained views of rock-cut temples that were based on Wales' views. This set of nine plates was published in 1803. As a contemporary reviewer wrote, the etchings of *Oriental Scenery* are "a profound study for the architect or antiquary and a source of delight to the lover of the picturesque."

While the Daniells were touring India, a number of skilled army officers with a taste for the picturesque were whiling away the tedious delays in military operations by painting the countryside around them. The Mysore Wars of 1767–99 were fought in an area of great rocky hills, fine waterfalls, and vast temples—an area quite unknown to the British public. An army officer, Robert Hyde Colebrooke (1762–1808), published *Twelve Views of Places in the Kingdom of Mysore* in 1794 (fig. 30). Also in 1794, Captain Alexander Allen (1764–1820) produced *Views in the Mysore Country*. In 1799, Sir Thomas Anburey (1750–1840), who was involved with fighting on the border between Mysore and Hyderabad, published *Hindoostan Scenery*, in which he depicted the great rocky passes (fig. 31) and gorges on the Pennar River. James Hunter died in 1792 in the Third Mysore War, but some of his drawings were published in 1804–05 as *Picturesque Scenery in the Kingdom of Mysore* or included with Blagdon's *A Brief History of Ancient and Modern India* (fig. 32). When the wars were over, Henry Salt (1780–1827) accompanied George Annesley, Viscount Valentia, as his official artist on a 'grand tour' of the East that included India. He made delightful fresh watercolors of India, ten of which were etched and included in *Twenty-Four Views in St. Helena, the Cape, India, Ceylon, the Red Sea, Abyssinia, and Egypt*, 1805 (figs. 33–36).

Shikar or hunting scenes, such as Captain Thomas Williamson's *Oriental Field Sports*, 1805, provided more subjects for picturesque scenes. Williamson himself was a keen sportsman, and his drawings, later worked up by Samuel Howitt (1765–1822), admirably catch the feel of the cool season in the Indian villages and jungles (fig. 37).

As British administration spread, a journey up the Ganges by a kind of houseboat known as a 'budgerow' became one of the most popular methods of travel, for it revealed a succession of picturesque views that could be sketched in comfort from the boat. Particular scenes that attracted amateur artists were the waterfall of Moti Jarna, the dangerous rocks at Colgong (where Mrs. Warren Hastings once almost drowned in a storm), the Fakir's Rock at Sultanganj, the *ghats* at Benares, and fine monuments at Lucknow and Delhi, culminating in a view of the Taj Mahal at Agra. Numerous sketchbooks were filled with charming watercolors of the many ruins, small tombs, and great banyan trees that were seen on the way. *A Picturesque Tour along the Rivers Ganges and Jumna* by Colonel Charles Forrest (active

1802–1827) was published in 1824 and is typical of this genre (figs. 38–40).

All these prints about India take their place alongside the fine books illustrating picturesque scenes of Europe that were proving so successful in Britain at this time, but, with their Oriental subjects, they make a unique contribution to the cult of the Picturesque and the Sublime.

Widening Vistas

As the years passed and British administration gradually spread over India, other illustrated books were produced, depicting scenes in the newly acquired areas. After the Nepal War of 1814–16, James Baillie Fraser joined his brother William, political agent to General Martindale during the war and now Commissioner for the territory of Garhwal, which was newly under British control, for a long adventurous tour through one of the loveliest areas of the Himalayas. James sketched indefatigably all the way. He followed the valleys of the Touse and Pabur Rivers to the sources of the Jumna and Ganges near Jumnotri and the great mountain of Bunderpunch—areas that were quite unexplored at this date. On his return to Calcutta in late 1816, James took art lessons from Chinnery and Havell and worked up his sketches into full romantic watercolors. After he returned to England, he published them in aquatint form in 1820 as *Views in the Himala Mountains* (fig. 41). They depicted a completely unknown area of India. Together with the Daniells' *Oriental Scenery*, this great publication included some of the finest and most impressive aquatints ever made of India.

Another development that led to additional picturesque views for illustrated books was the opening of the hill stations. Simla had been founded in 1832, and many English ladies, exiled there during the hot weather on the Plains, painted the great cedar forests, the picturesque wooden temples, and the towering hills, especially Mount Jakko. Mrs. W.L.L. Scott, a general's wife, was a keen watercolorist, and a number of her drawings were eventually lithographed and published in 1852 as *Views in the Himalayas* (fig. 42).

In the south a hill station began to develop from around 1820 at Ootacamund in the Nilgiri Hills. A group of the loveliest aquatints ever made of India was published in 1835 as *Views in India, chiefly among the Neelgherry Hills*, after drawings by Captain Richard Barron (active 1815–1838), Aide-de-Camp to the governor of Madras. These show the new hill station: a little group of bungalows nestled around a blue lake

among rolling hills. For the British this area was a kind of Indian Arcady, inhabited by the Todas, a simple, gentle tribe who lived in beehive-shaped huts and grazed cattle. Barron's charming aquatints invest the whole area with a romantic glow, and an air of hushed enchantment pervades the scene (fig. 63). It is not surprising that for some of the British the region of the Nilgiri Hills was one of the most attractive in India.

With the gradual spread of British administration into Central India, Rajasthan, the Deccan, and Gujarat across to Bombay, countless new areas provided British amateur artists with a plethora of new and stimulating material for sketching. Captain Robert Grindlay's *Scenery, Costumes, and Architecture*, 1826–30, brought together a wide range of landscapes and architecture and reflects this development (figs. 43–52). It included aquatints of Bundi, Tonk, Mount Abu, Aurangabad, Ahmedabad, Baroda, and Golconda, in addition to antiquities around Bombay. Some of the views were by Grindlay himself, others by William Westall (1781–1830) and Lieutenant-Colonel John Johnson (c.1769–1846). (See figs. 44, 45, 48.) Many prints clearly reveal a new interest in the various forms of architecture that the British were now encountering, and it is significant that the frontispiece of Grindlay's book takes the form of an architectural capriccio mingling Muslim and Hindu styles (fig. 43). The administration of Cutch was brought under the British in 1834, and Mrs. Marianne Postans (active 1837–1857), wife of a Company servant, produced her book on this area in 1839. Her husband was a keen amateur archaeologist, who had entered the Bombay Native Infantry in 1829. Sind was annexed in 1843, and Lieutenant William Edwards produced his *Sketches of Scinde* three years later. When Kashmir and the Himalayas became accessible, following the Sikh Wars of 1845–46, Kashmir became one of the favorite holiday places of the British. Its lotus-studded lakes, its willows and poplars silhouetted against the snow-capped mountains were avidly sketched by British artists. Although a few views of it were published in *Recollections of India*, 1847 (fig. 53), by Charles Hardinge (1822–1894), Aide-de-Camp to his father the Governor-General, Lord Hardinge, it is to the unpublished drawings of many amateurs and to the watercolors of William Simpson (1823–1899) that one must look for views of Kashmir. Sadly, access to this beautiful area came at the very moment when the vogue for the illustrated book was nearing its end. Charles Francis produced his *Sketches of Native Life in India with Views of Rajpootanah, Simla, etc.* in 1848. *Sketches of Afghaunistan* was published by James Atkinson in 1842 after the disastrous Afghan War of 1839. Lieutenant James Rattray (1818–1854) of the 2nd Bengal Native Infantry produced *Scenery, Inhabitants & Costumes, of Afghaunistan* in 1847–48 (figs. 66, 67).

By the middle of the nineteenth century the vogue for the great illustrated book had come to an end. Its decline is reflected in the career of William Simpson, who had been sent to India by the publishing and lithographic firm of Day and Son two years after the Indian Mutiny of 1857 to make drawings of areas that were of topical interest to the British. The plan was to publish four folio volumes, containing 280 chromolithographs, which would rival Daniell's *Oriental Scenery*. Simpson worked hard, traveled widely, and returned to England with sketchbooks full of lively drawings. He settled down to working them up into full watercolors, but only 50 were used for *India, Ancient and Modern*, 1867; the rest were sold off by the publishers as bankrupt stock. Although Simpson's original drawings and watercolors are highly skilled and sensitive, the resulting prints by chromolithography (figs. 70, 71) are crude compared with the fine aquatints of the earlier period. With Simpson's work the great vogue for the illustrated book on India came to an end. His publication was the last example of this delightful genre, and it is significant that it coincided with the abolition of the East India Company. By the mid-nineteenth century the art training of the young civil servants and military officers destined for India had given way to instruction in photography. At the same time, imperialistic attitudes were gaining ground, and the old interests in archaeology and the Picturesque were waning. These changing attitudes were the death knell of the great illustrated book.

The People

Picturesque landscape was not the only subject of the great illustrated books. The British were particularly fascinated by the diverse peoples they encountered in India, as well as by their picturesque costume and unusual occupations. There was, in fact, at this time in England a keen interest in all kinds of trades and occupations, and many illustrated books were devoted to the subject. In 1773, for example, Thomas Jefferys published *A collection of the different dresses of different nations especially Old English Dresses*, while *Picturesque representations of the Dress and Manners of the English* was published in 1814. It is not surprising that many British artists sought out similar subjects.

A print after an oil painting by John Zoffany (1733–1810) provides a fascinating conspectus of Lucknow society (fig. 54). It depicts a cockfight held at the court of Asaf-ud-daula, the Nawab of Lucknow, on April 5, 1784. Warren Hastings, the Governor-General, had had to visit Lucknow that year to restore order to the Nawab's finances and settle his debts to the East India Company. It seemed a good opportunity to take along

John Zoffany, who was in Calcutta, so that the artist could encounter new scenes and perhaps secure new commissions. Soon after arriving, Hastings and Zoffany were invited to watch a cock-match between the cocks of the Nawab and those of Colonel Mordaunt, Commander of the Nawab's Bodyguard. Mordaunt was a favorite of the Nawab and shared his enthusiasm for this sport. Bouts were held regularly and attended by all the leading members of the Lucknow community, both Indian and British. It was a great opportunity for Zoffany to sketch many different types of people. Zoffany stayed on in Lucknow after Hasting's return to Calcutta, and between 1784 and 1786 he worked up two oil versions of his cockfight sketch—one for Hastings and one for the Nawab. They are an exciting evocation of the event and include portraits of all the leading European and Indian members of Lucknow society, as well as of dancing-girls and musicians. Zoffany included a portrait of himself sitting on the far right, clearly taking little interest in the cockfight but quietly absorbing the whole scene. Later, in 1792, after his return to England, a print was engraved from one of the oils.

Numerous other prints after drawings by the British document the diverse types of people in India and their occupations. They were used to illustrate the many memoirs published at this time. In his *Oriental Drawings* of 1806, Charles Gold (died 1842) included 24 aquatints depicting various types of ascetics (fig. 57), sepoys, jugglers, snake charmers, and Indian women (fig. 58).

While Sir Charles D'Oyly was in Patna, he ran a British art society lightheartedly known as "The Bihar School of Athens." He imported a lithographic press and trained a Patna artist, Jairam Das, to operate it and reproduce on it drawings by the society's members. Many of these depicted occupations such as juggling and making pots (figs. 60, 61) and were printed in a periodical entitled *The Bihar Amateur Lithographic Scrapbook*. He also trained Patna artists to make paintings of costumes and occupations in a semi-European style. These "Company Drawings," as they are now called, were frequently purchased by European travelers going upcountry on riverboats by way of Patna. The artists themselves marketed them at the various stopping places on the river.

Colonel John Luard (1790–1875) was another skilled amateur. Fanny Parks (1794–1875) had met him on her voyage to India in 1833 and been greatly impressed by his skill. She was later given a copy of his book, *Views in India, St. Helen and Car Nicobar*, 1837, which included lithographs he had made himself. She much admired his drawing, "Itinerant Snake Catchers" (fig. 62), and noted in her diary: "I have just received a present of Colonel Luard's most beautiful views in India: how true they are! His snake catchers are the very

people themselves." Fanny herself was a highly competent artist, and in her *Wanderings of a Pilgrim in Search of the Picturesque*, 1850, she reproduced pictures of a Bengali woman and a sword-bearer (fig. 68).

As the British opened new areas in India, they encountered and recorded novel types of people, costumes, and occupations. Captain Barron, for example, included a picture of Todas in his *Views in India, chiefly among the Neelgherry Hills*, 1837 (fig. 63). James Rattray included pictures of Afghans in his *Scenery, Inhabitants, & Costumes of Afghaunistan*, 1847–48, ranging from hawkers to the King of Kabul (figs. 66, 67). Most important of all was a much earlier work by François Balthazar Solvyns, *A Collection of Two Hundred and Fifty Coloured Etchings Descriptive of The Manners, Customs and Dresses of the Hindoos*, published between 1795 and 1799. In addition to pictures of the various castes and occupations, Solvyns included the many kinds of ascetics who could be seen in Bengal, the players of diverse types of musical instruments, and various kinds of transport both on land and water. Despite its wide-ranging subject matter, however, the book was not a success. The British public clearly did not find the pictures, with their somber sepia coloring, attractive enough. One critic complained that the drawings were 'rude.' As a result, between 1804 and 1805, Edward Orme produced a new and smaller-sized version of the book, entitled *The Costume of Hindostan*, which contained copies of Solvyns' figures by William Orme. The drawing was more professional and the coloring more attractive, with pinks, mauves, and greens replacing the sepia of Solvyns' plates. Yet Solvyns' prints gave a far more comprehensive survey of the subject, and his drab figures, conveying a sense of sadness (1810–11 ed.; figs. 55, 56), are a far more realistic and moving record of the Bengal villager and city-dweller than Orme's prettified version. Today Solvyns' great book has come to be regarded as a significant work.

Perhaps the most attractive and popular prints depicting Indian people are to be found in the portfolio, *Portraits of the Princes & People of India*, 1844, by Emily Eden (1797–1869). Emily was the sister of Lord Auckland, Governor-General of India from 1836 to 1842. She and her sister Fanny accompanied him on his great tour "up the country" from October, 1837, to March, 1838, when he visited the Punjab and the Sikh court. Emily Eden was an accomplished artist, and her lithographs, with their attractive subjects and gay coloring, provide a lively record of the picturesque characters the three encountered during their long tour (fig. 65). She portrays the many princes they met, such as the Raja of Patiala and the Sikh ruler Ranjit Singh and his relations, Hira Singh and Sher Singh. But she also includes ascetics, hawkers, camel messengers, Arab servants, Tibetans, Pathans, and the handlers of hunting leopards. All appear in this colorful survey of the long tour.

William Simpson, who visited India between 1858 and 1862, had a similar zest for recording people. A few of his sketches, such as those of Jains and passersby in the Calcutta streets, were included as chromolithographs in his *India, Ancient and Modern*, published after his return to England in 1867 (figs. 70, 71), but it is the drawings in his sketchbooks, with their lively line and flowing washes of watercolor, that best record the Himalayan people, Thugs, Sikhs, children, and many others whom he sketched during his long adventurous tours in India. It is sad that these drawings were never published and given greater publicity, but the vogue for the Picturesque was dying.

However, an interest in recording the way of life of the British was developing. As early as 1813, drawings by Sir Charles D'Oyly of the British with their servants were published in *The European in India*. In 1824 William Tayler (1808–1892) published his *Sketches Illustrating the Manners & Customs of the Indians & Anglo-Indians Drawn on Stone from the Original Drawings from Life*. In addition to pictures like "Women Grinding at the Mill," "The Sunyasees," and "The Village Barber," Tayler included three plates of "The Young Civilians [*sic*] Toilet" (fig. 64), "The Young Lady's Toilet," and "The Breakfast." Tayler had tongue in cheek when he published these drawings. He was very liberal in his views and deplored the widening gulf in the mid-nineteenth century between the British and the Indian public. "The great mass," he wrote, "see or hear of functionary after functionary coming and going, and holding the destinies of the people in the hollow of their hands, but they seldom, perhaps never, know what it is to feel that the minds of their rulers have ever been directed to understand or sympathise with the great heart that is beating around them." This attitude was expressed more lightheartedly by George Atkinson (1822–1859) in *Curry & Rice (on forty plates) or the Ingredients of Social Life at 'Our' Station in India* (fig. 69). All these books, from which plates exhibited here have been taken, provided a wide and unique view of India and its people that is as stimulating today as it was in the eighteenth and nineteenth centuries.

Historical Events

At the end of the eighteenth century the British were passing through a period of self-confidence and optimism. The defeat of British troops during the Second Mysore War (1790–92) greatly jolted this jingoistic optimism. When at last, in 1792, Lord Cornwallis advanced on Bangalore and Seringapatam, and Tipu Sultan was forced to surrender his two young sons as hostages, there was great rejoicing in England. The event caught the popular imagination, and a number of somewhat sentimental oil paintings were made by Robert Home, Arthur W. Devis, Henry Singleton, and Mather Brown. Engravings were quickly made after these oils, and two by an engraver named J. Grozer depicted Tipu Sultan's sons being taken from him and a kindly, avuncular Lord Cornwallis receiving the little princes as hostages (fig. 73).

Even more popular were engravings after paintings illustrating the siege and eventual capture of Seringapatam in 1799. Robert Ker Porter (1777–1842) painted a large panorama depicting the siege, which was engraved by Giovanni Vendramini and published in three separate sections. When Tipu Sultan was killed near the Hoally Gateway of the Fort during the successful storming of Seringapatam by General Harris on May 4, 1799, Sir David Wilkie made a large oil painting of Sir David Baird discovering the body. That painting was engraved by S.W. Reynolds. Another painting by Sir Robert Ker Porter shows the body of Tipu being identified by his family, and it was engraved by Luigi Shiavonetti and Anthony Cardon (fig. 74). These prints were particularly popular in England, appealing to the patriotic fervor of the day.

Military events such as the Sikh Wars of 1848–49 were also popular subjects for engravings. The Battle of Chillianwala took place on January 13, 1849, under the command of Lord Gough. A print was made of this battle (fig. 75) by Henry Martens (died 1860), an artist who gained a great reputation for painting military events and army uniforms. The British forces suffered severely at Chillianwala. Lord Gough lost four guns and the colors of three regiments, and he was recalled immediately, but before Sir Charles Napier could come out to replace him, Gough brought the war to an end on February 21 by winning the Battle of Gujarat.

Various stages of the Indian Mutiny of 1857 were also recorded in fine prints. The Mutiny was perhaps the greatest disaster the British ever suffered in India. Not surprisingly, there was keen interest in England in the terrible events, especially in the siege of Lucknow, which dragged on for three months during the hot weather and rains. At last, on September 25, Generals Outram and Havelock forced their way through the Indian lines into the city, but it was November before Sir Colin Campbell could finally raise the siege. Even then the city could not be held, and the troubles were not brought to an end until March, 1858. A number of imaginary depictions of the Lucknow events were painted or engraved in England, one of the most popular volumes of engravings being Clifford Meecham's *Sketches in India of the Siege of Lucknow*.

By the 1860s the vogue for the great illustrated book had come to an end. Photography had been invented and was rapidly killing painting by amateurs. In England, for example, the East India Company's recruits

were being instructed at their colleges in the use of the camera instead of in painting. At the same time, interest in the Picturesque was being superseded by political and social interests concerning the government of India and its people. The change was reflected, for example, in the fate of William Simpson's drawings. His publisher, Day and Son, had originally planned a great publication of some 280 chromolithographs based on his drawings. In the end only 50 were engraved, as the publishers came to understand that it was Politics rather than the Picturesque that was now interesting the British public. Today, however, tastes have changed once again, and it is the fine illustrated books and separate prints of India that are arousing interest and admiration. It is realized that these are not only among the most beautiful engravings ever published but that they are important for having created a poetic vision of India that has persisted until the present day.

DR. MILDRED ARCHER
London, 1986

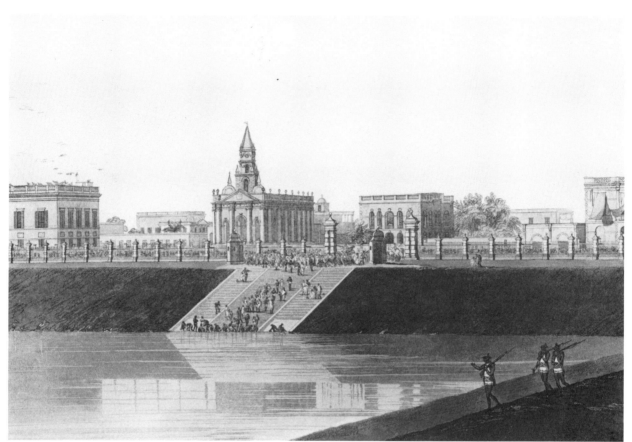

1 T. Daniell, *Part of the Old Tank,* cat. 4

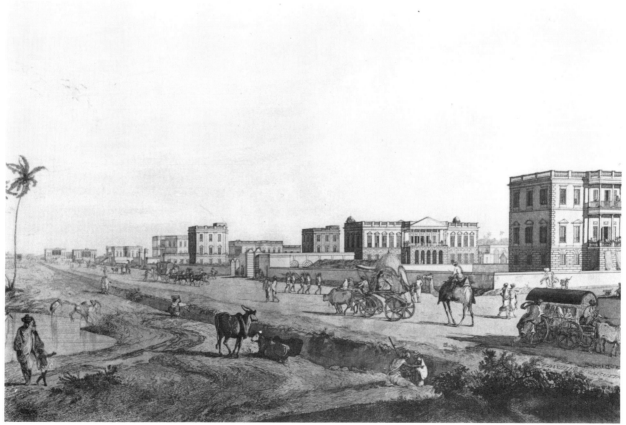

2 T. Daniell, *The New Buildings at Chouringhee,* cat. 5

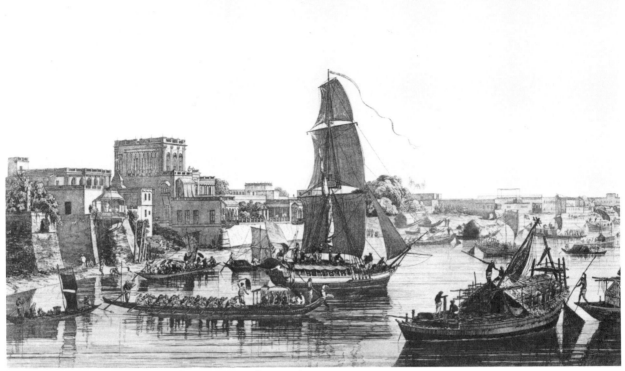

3 T. Daniell, *Calcutta from the River Hoogly*, cat. 6

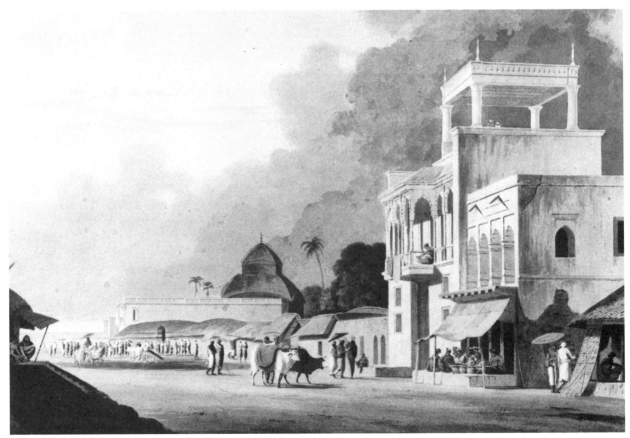

4 T. & W. Daniell, *View on the Chitpore Road*, cat. 9

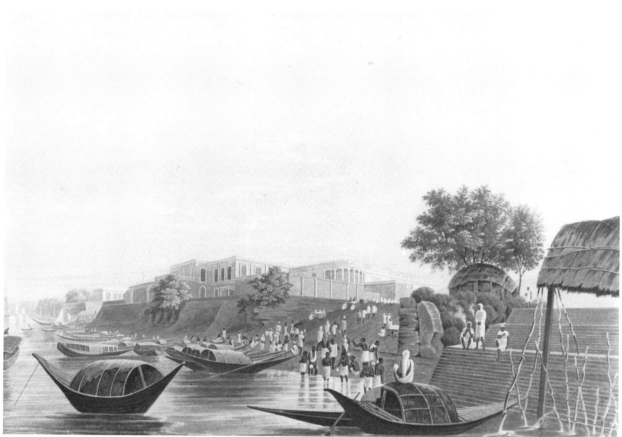

5 J. Fraser, *A View of Chandpal Ghat*, cat. 49

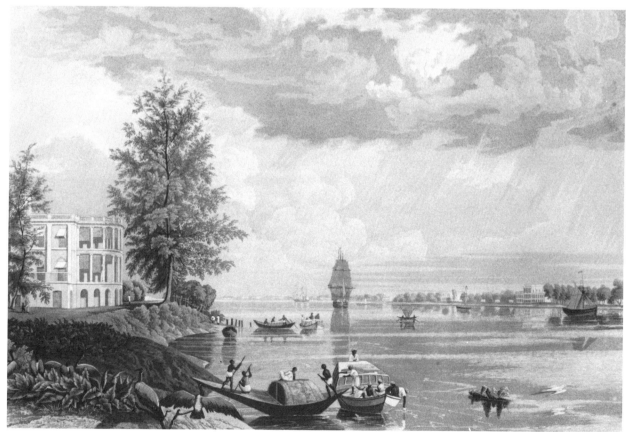

6 J. Fraser, *Botanic Garden House and Reach*, cat. 50

19

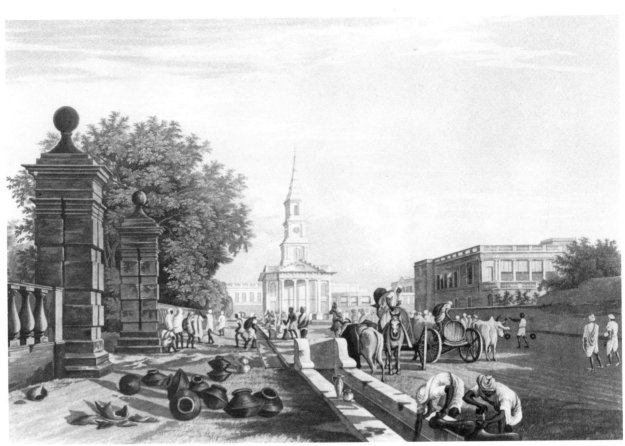

7　J. Fraser, *Scotch Church, from...Tank Square*, cat. 51

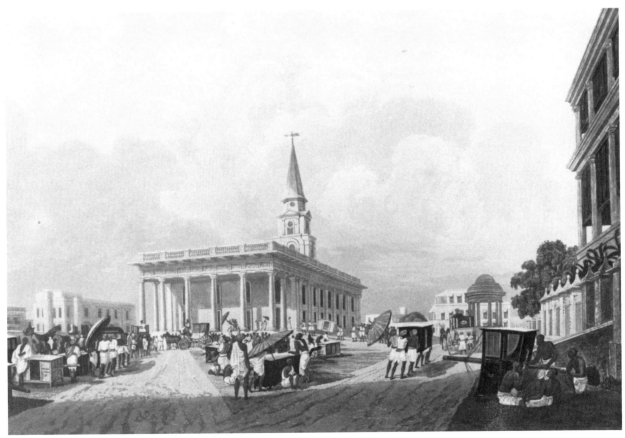

8　J. Fraser, *View of St. John's Cathedral*, cat. 52

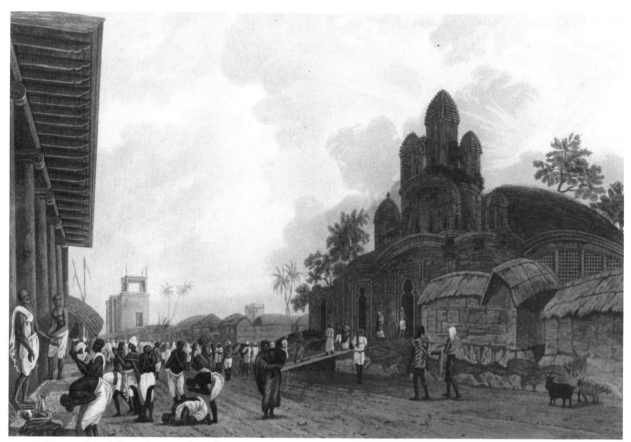

9 J. Fraser, *Black Pagoda, on the Chitpore*, cat. 53

10 C. D'Oyly, *East Gate*, cat. 43

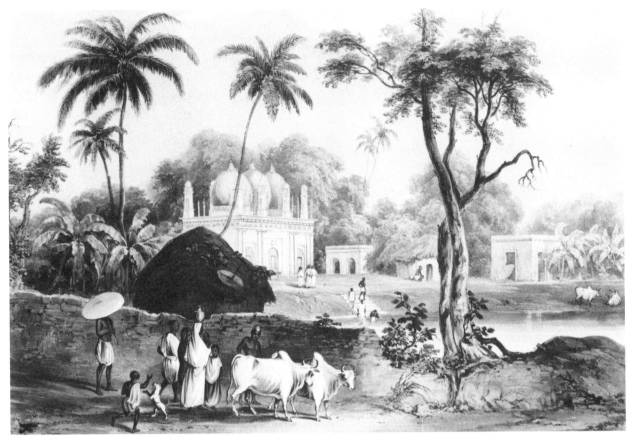

11 C. D'Oyly, *Mosque at Borranypore*, cat. 44

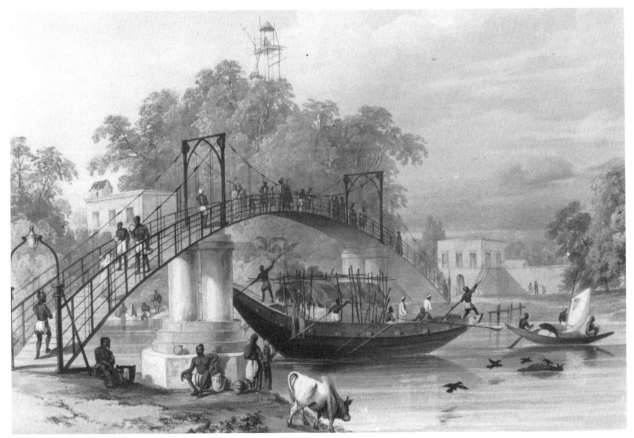

12 C. D'Oyly, *Suspension Bridge...Tolly's Nulla*, cat. 45

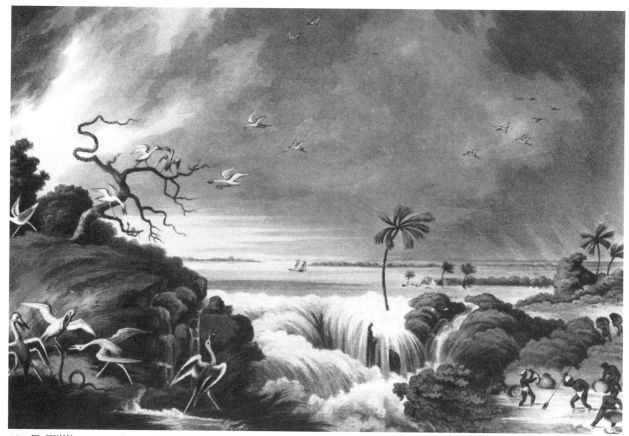

13 T. Williamson, *Ganges Breaking its Banks*, cat. 30

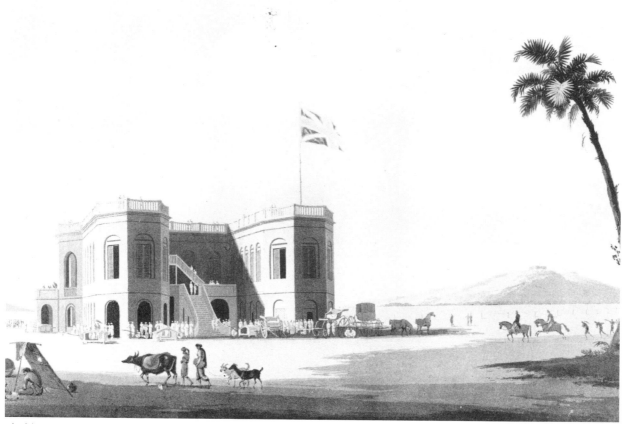

14 T. & W. Daniell, *The Assembly Rooms...Madras*, cat. 12

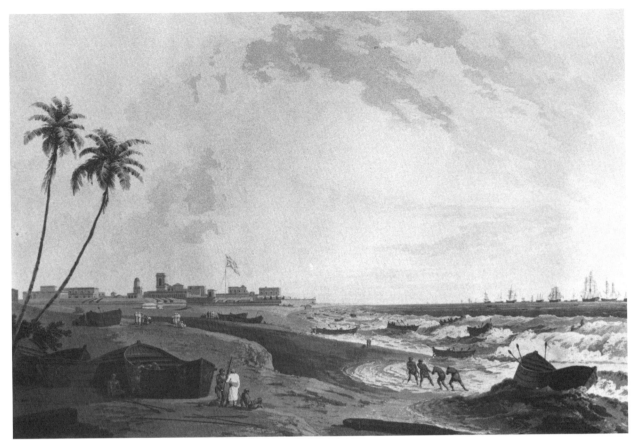

15 T. Daniell, *Fort St. George, Madras*, cat. 10

16 F. Ward, *St. Thomé St., Fort St. George*, cat. 28

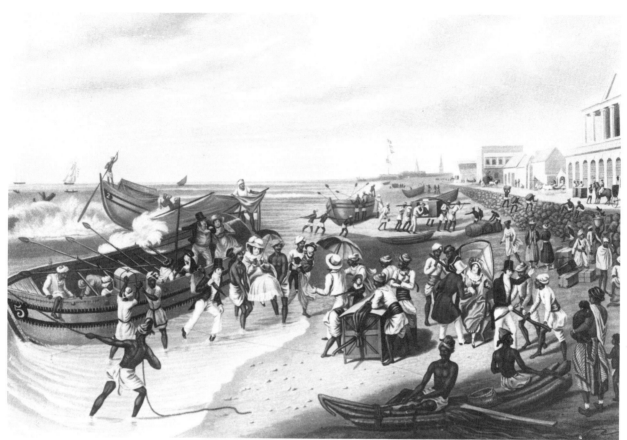

17 J. B. East, *Madras Landing*, cat. 73

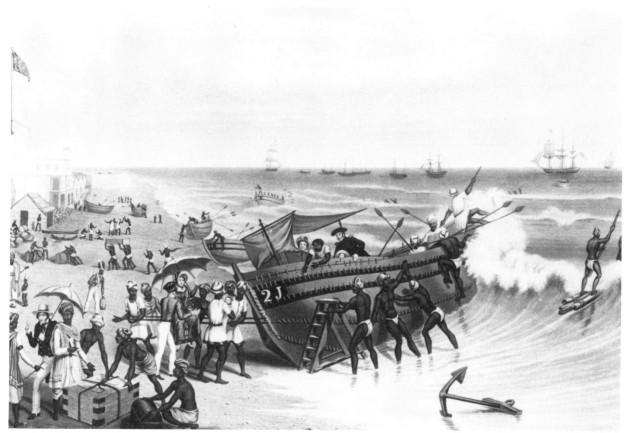

18 J. B. East, *Madras Embarking*, cat. 74

19 W. Hodges, *Farm-Yard...Bengal*, cat. 2

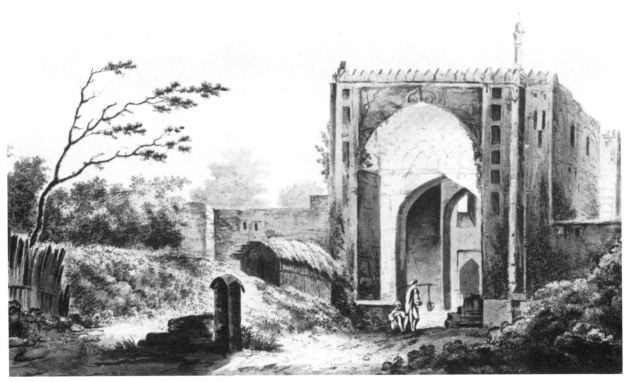

20 W. Hodges, *Gate...at Raje Mahel*, cat. 1

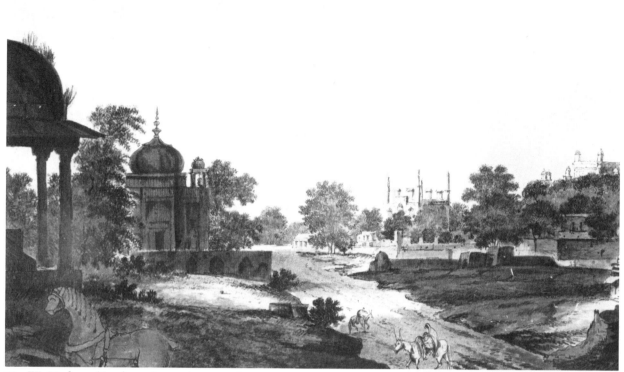

21 W. Hodges, *Tombs at Secundru near Agra*, cat. 3

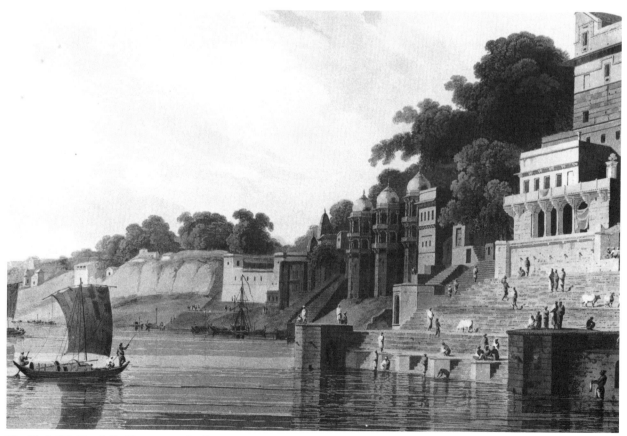

22 T. & W. Daniell, *Dusasumade Gaut, at Bernares*, cat. 8

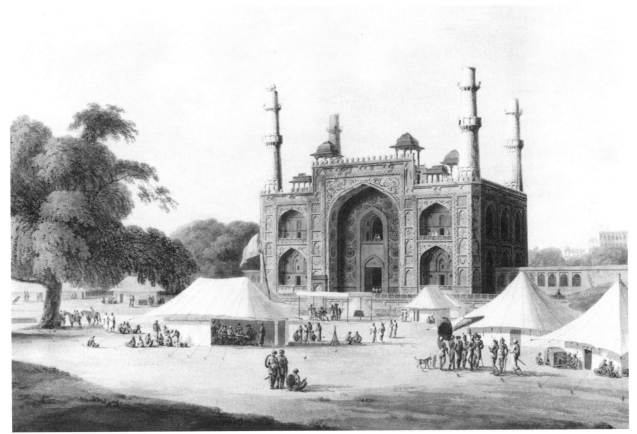

23 T. & W. Daniell, *Tomb of Emperor Akbar, at Secundra*, cat. 7

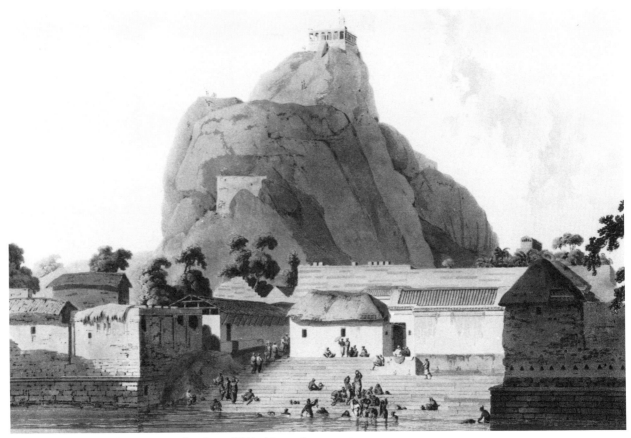

24 T. & W. Daniell, *View in the Fort of Tritchinopoly*, cat. 13

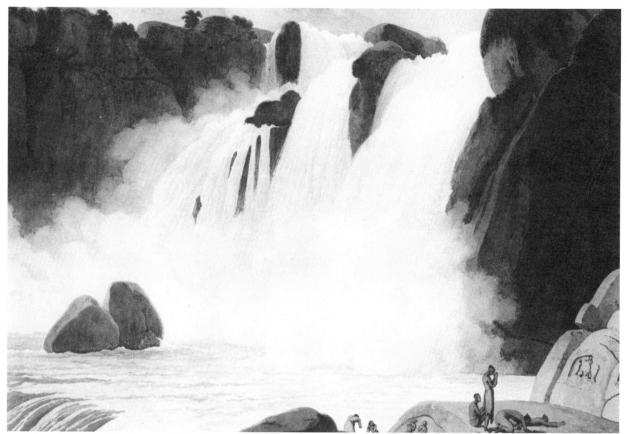

25 T. & W. Daniell, *Water-Fall at Puppanassum*, cat. 19

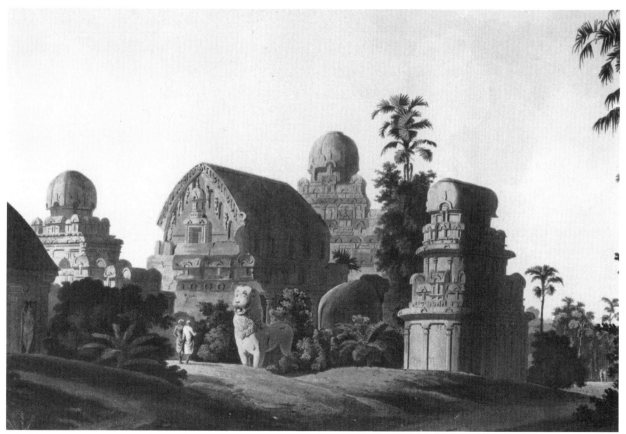

26 T. & W. Daniell, *Sculptured Rocks, at Mavalipuram*, cat. 14

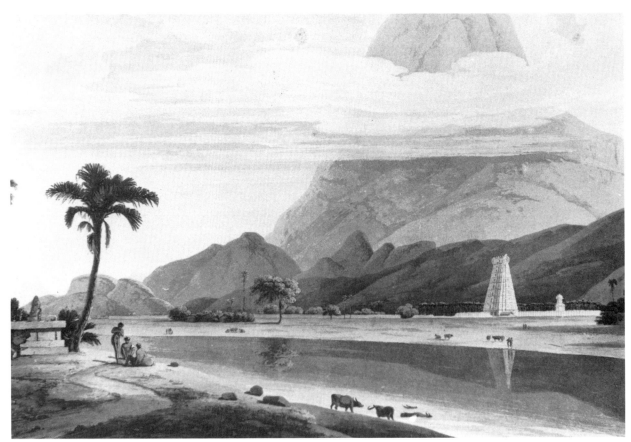

27 T. & W. Daniell, *Cape Comorin*, cat. 18

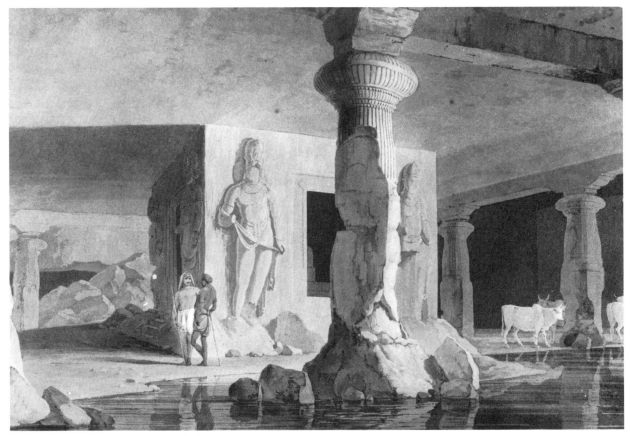

28 T. & W. Daniell, *Interior of the Elephanta*, cat. 16

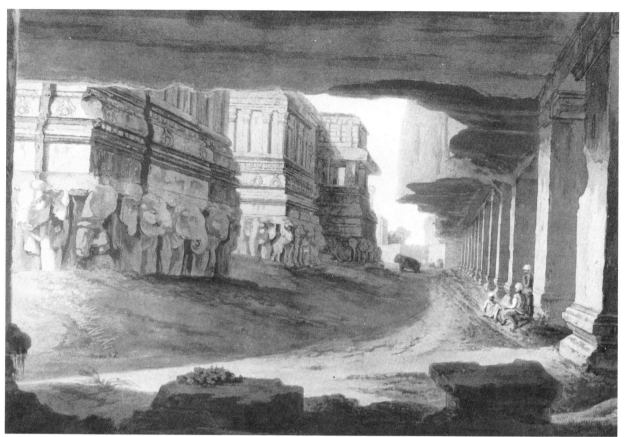

29 J. Wales, *N. E. View of Kailâsa*, cat. 17

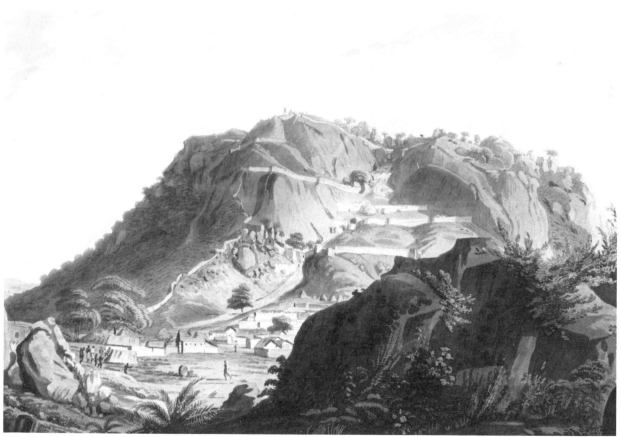

30 R. Colebrooke, *S. W. View of Ootra-Durgum*, cat. 21

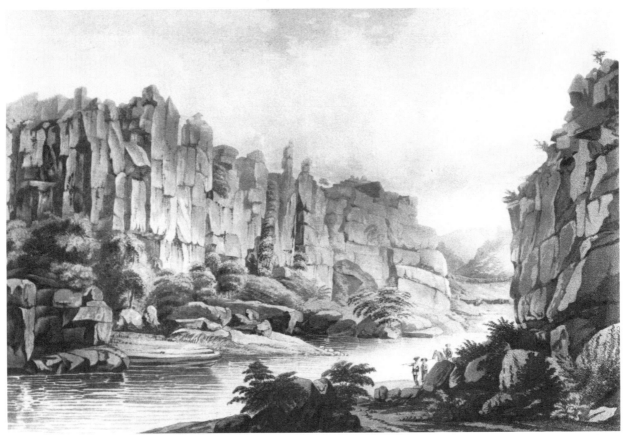

31 T. Anburey, *Gundecotta Pass*, cat. 22

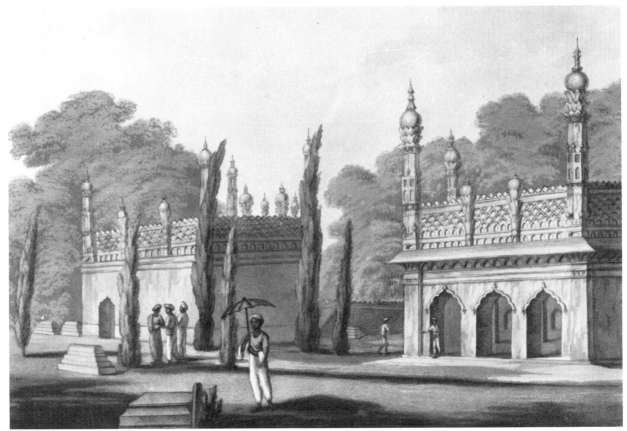

32 J. Hunter, *Hyder Ally Khan's own Family Tomb*, cat. 29

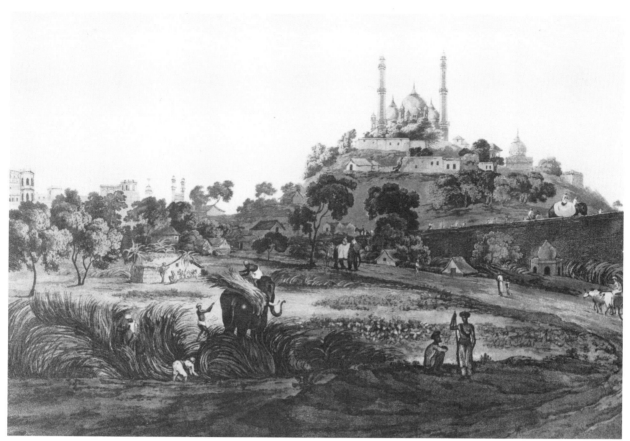

33 H. Salt, *A View at Lucknow*, cat. 35

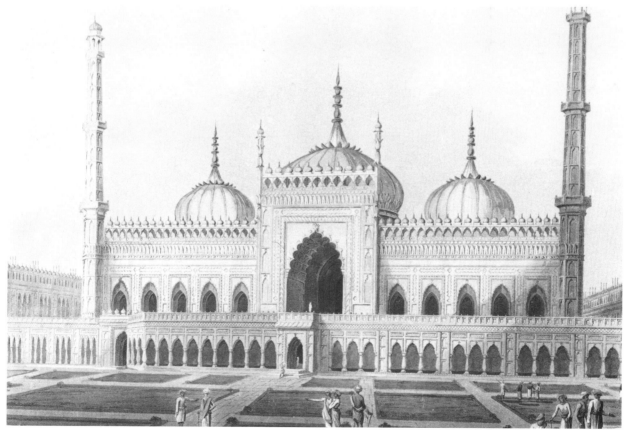

34 H. Salt, *Mosque at Lucknow*, cat. 36

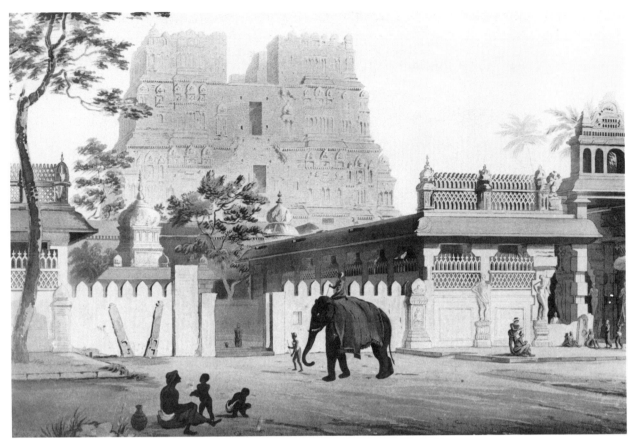

35 H. Salt, *Pagoda at Ramisseram*, cat. 37

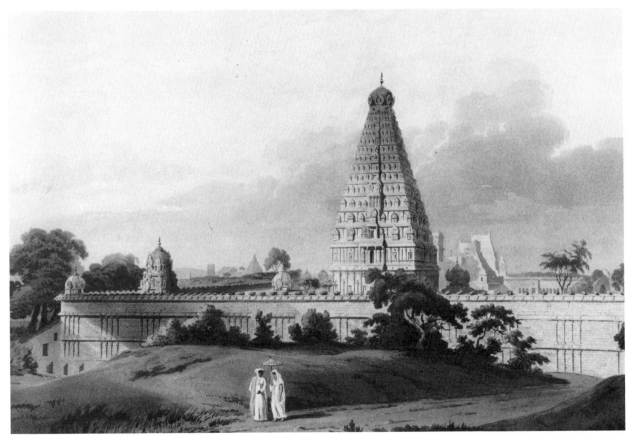

36 H. Salt, *Pagoda at Tanjore*, cat. 38

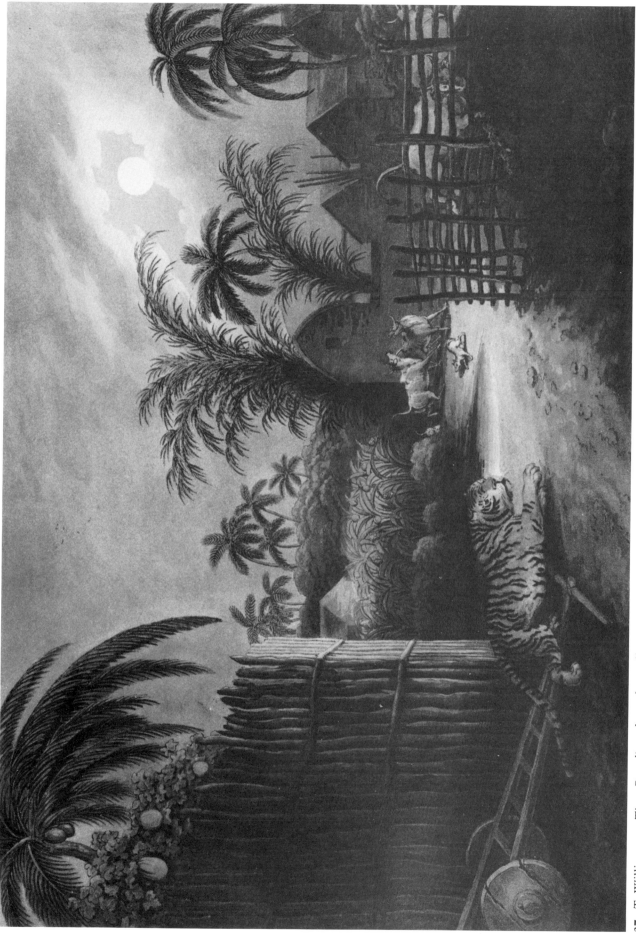

37 T. Williamson, *Tiger Prowling through a Village*, cat. 31

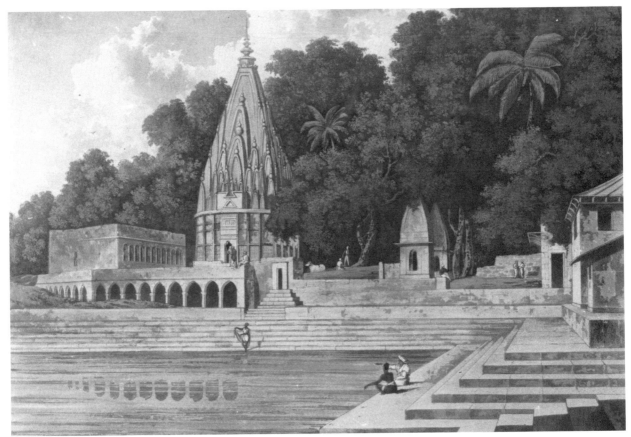

38 C. Forrest, *Sacred Tank and Pagodas near Benares*, cat. 55

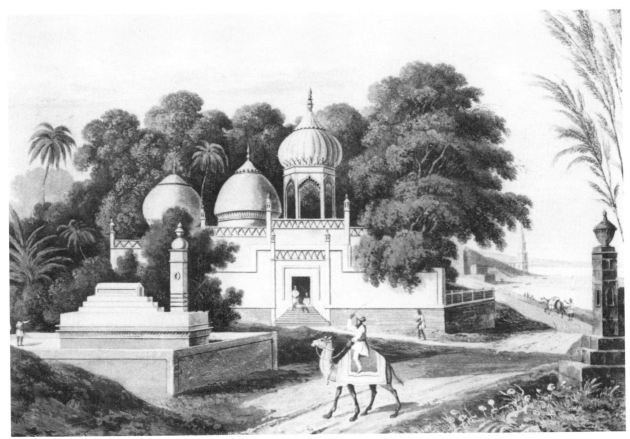

39 C. Forrest, *Mahomedan Mosque and Tomb...Benares*, cat. 56

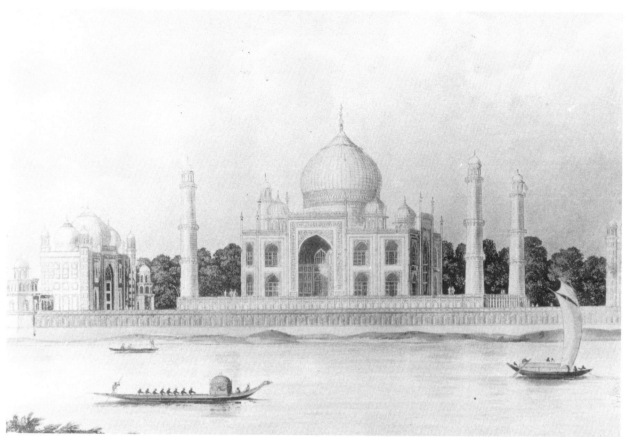

40 C. Forrest, *Taj Mahal*, cat. 57

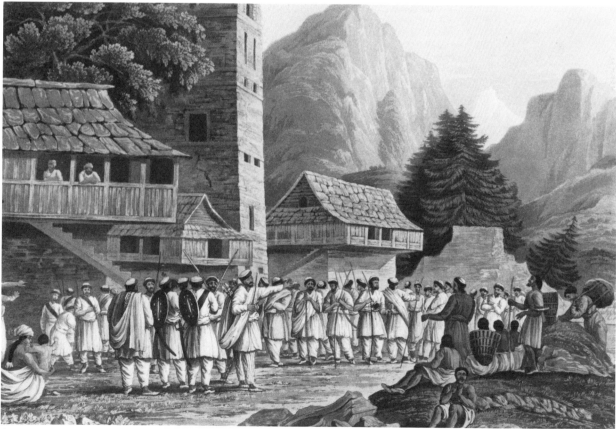

41 J. Fraser, *Assemblage of Hillmen*, cat. 48

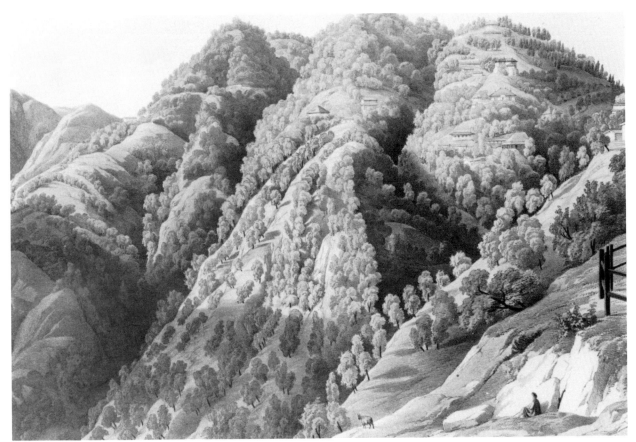

42 W. Scott, *Simla, the North Face of Jukko*, cat. 87

43 R. Grindlay, *Portico of a Hindoo Temple*, cat. 70

44 W. Westall, *Approach of the Monsoon, Bombay*, cat. 59

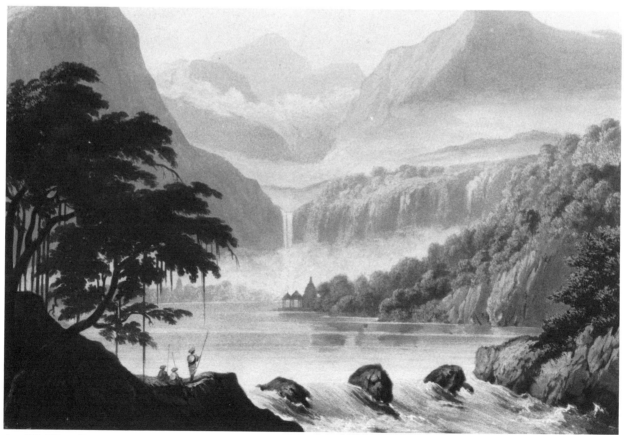

45 W. Westall, *Mountains of Aboo in Guzerat*, cat. 60

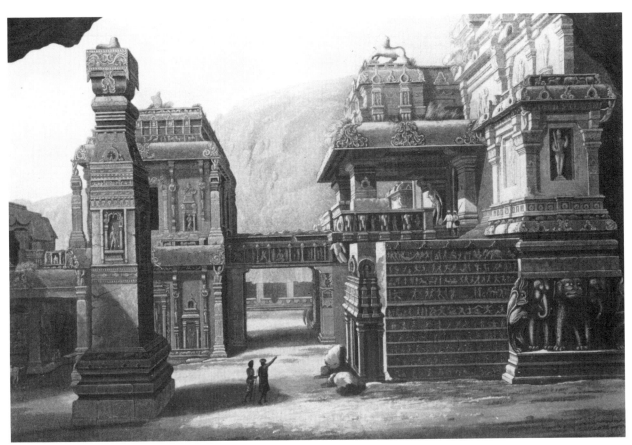

46 R. Grindlay, *Great excavated Temple at Ellora*, cat. 61

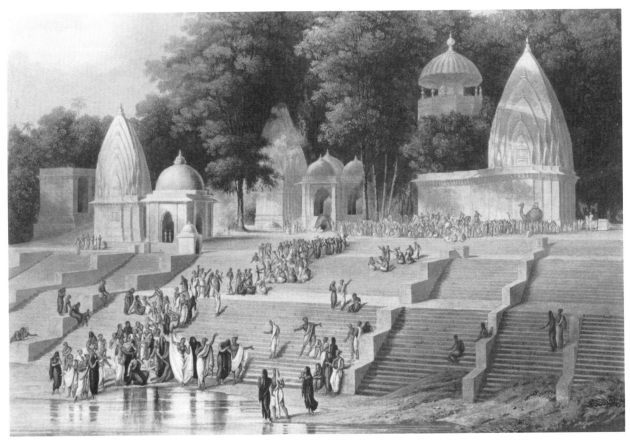

47 R. Grindlay, *Preparation for a Suttee*, cat. 62

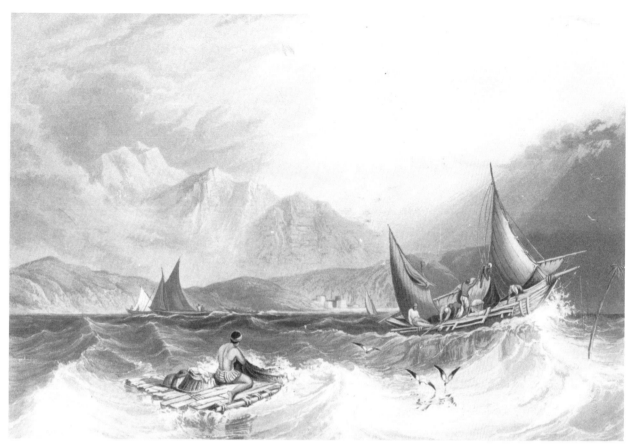

48 J. Johnson, *Fishing Boats in the Monsoon*, cat. 63

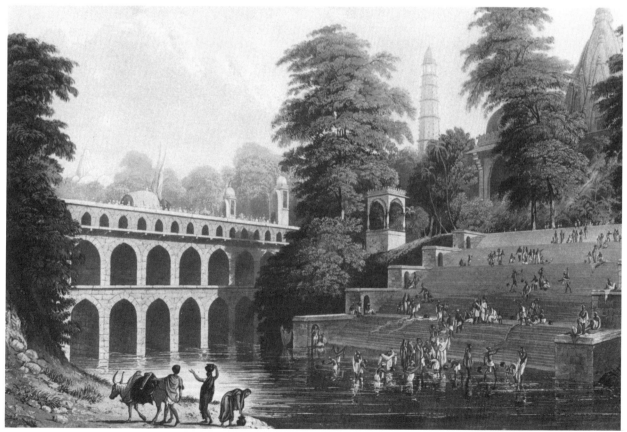

49 R. Grindlay, *View of the Bridge near Baroda*, cat. 64

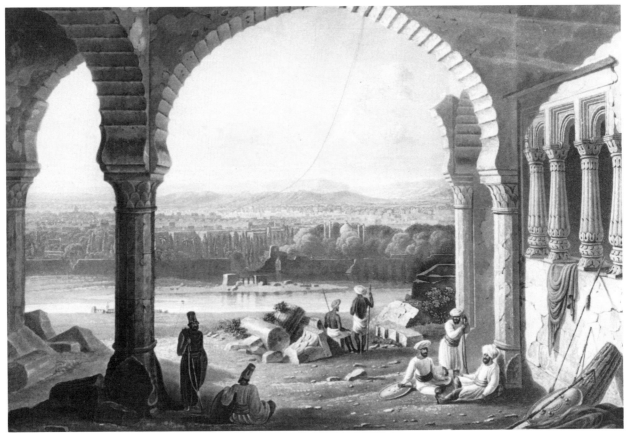

50 R. Grindlay, *Aurungabad*, cat. 66

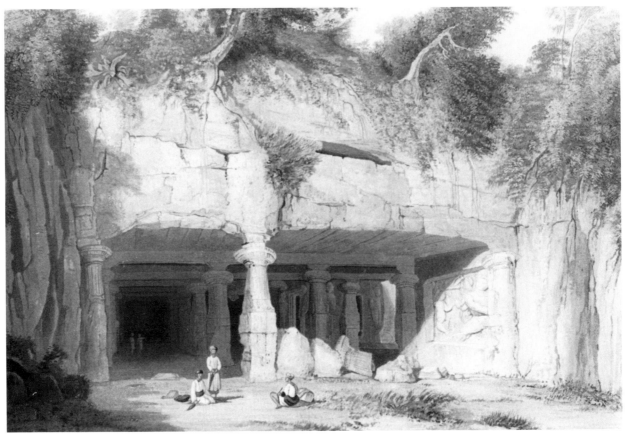

51 W. Westall, *Great Cave Temple of Elephanta*, cat. 67

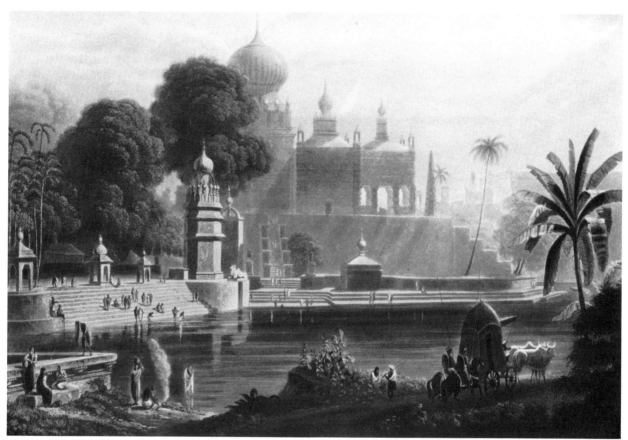

52 R. Grindlay, *View of Sasoor in the Deccan*, cat. 68

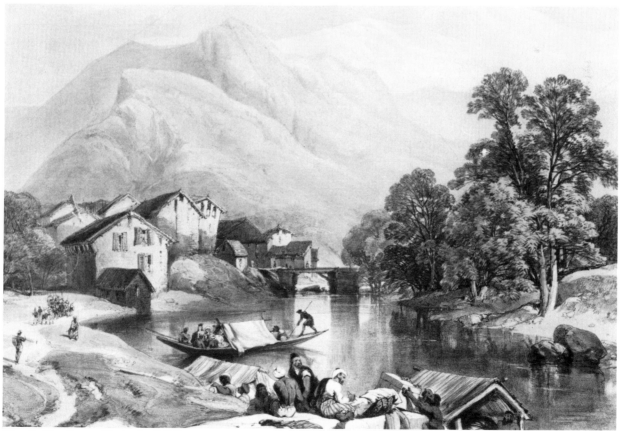

53 C. Hardinge, *Kashmir, Bij Beara*, cat. 80

43

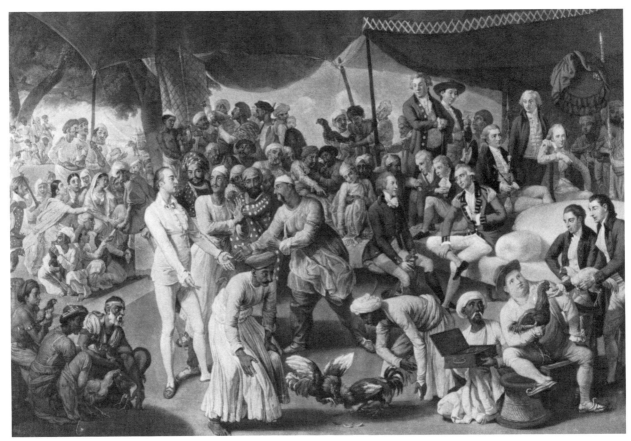

54 J. Zoffany, *Cock Fight...Lucknow*, cat. 94

55 F. Solvyns, *Femme de Distinction*, cat. 25

56 F. Solvyns, *Houka à tuyau*, cat. 26

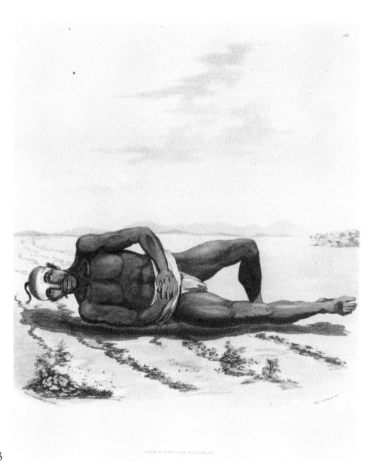

57 C. Gold, *A Gentoo Zealot*, cat. 33

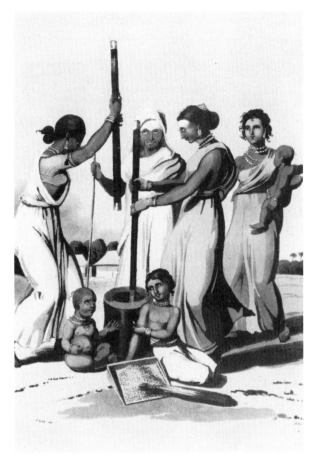

58 C. Gold, *Gentoo Women*, cat. 34

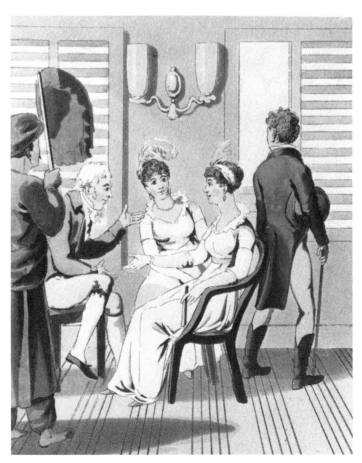

59 C. D'Oyly, *European Lady
attended by a Servant*, cat. 40

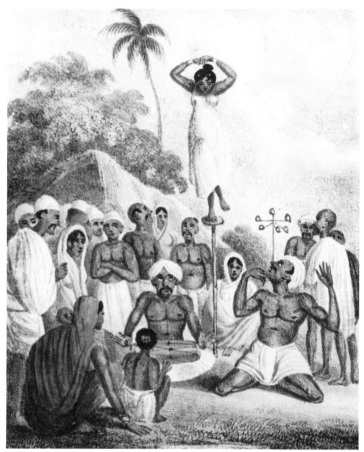

60 C. D'Oyly, *Nuts or Indian Jugglers*, cat. 41

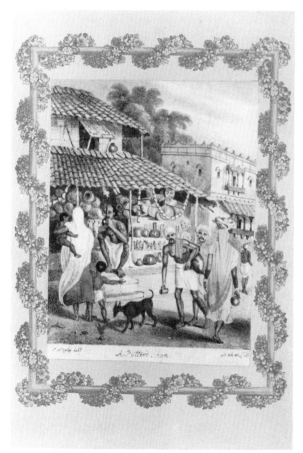

61 C. D'Oyly, *A Potter's Shop*, cat. 42

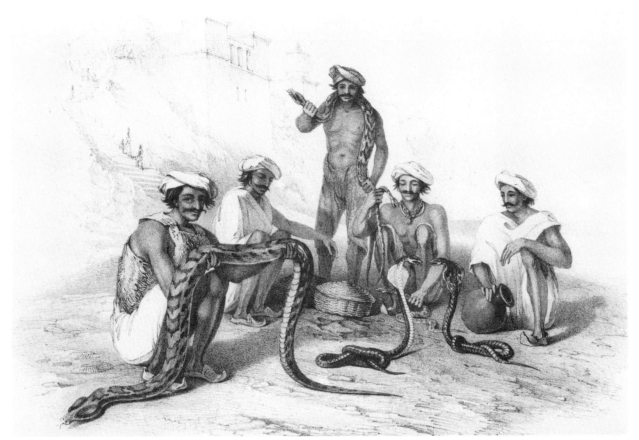

62 J. Luard, *Itinerant Snake Catchers*, cat. 71

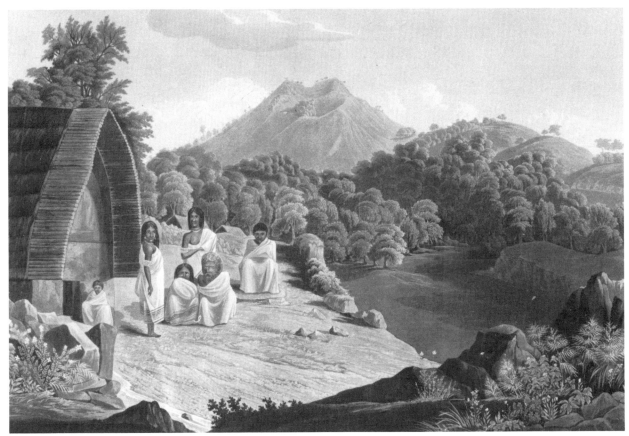

63 R. Barron, *Taken at Kandelmund...Toda Family*, cat. 72

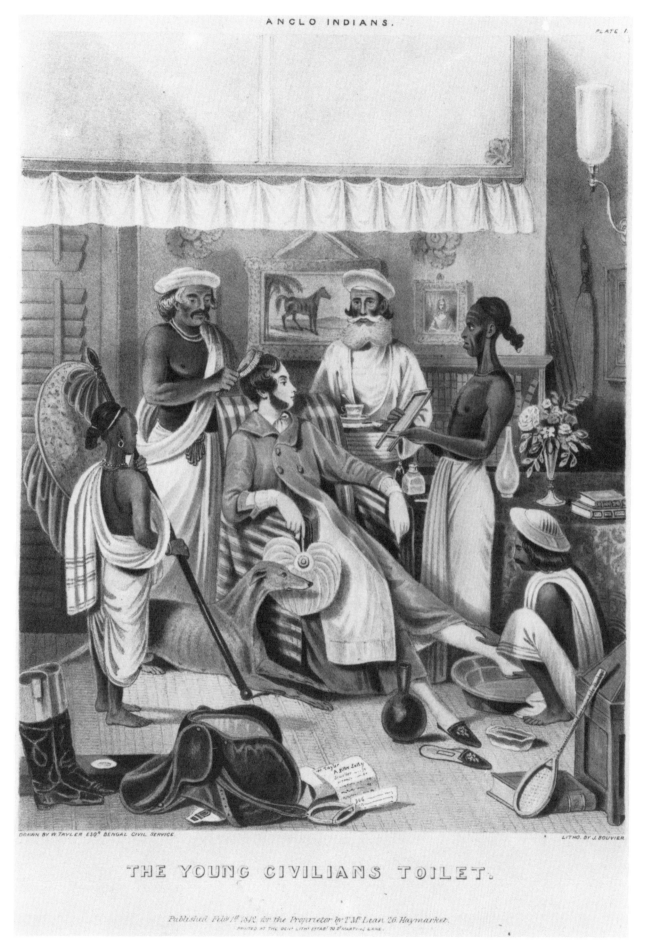

64 W. Tayler, *The Young Civilians Toilet*, cat. 76

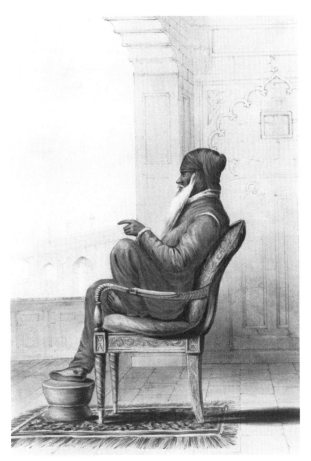

65 E. Eden, *Late Maha Raja Runjeet Singh*, cat. 79

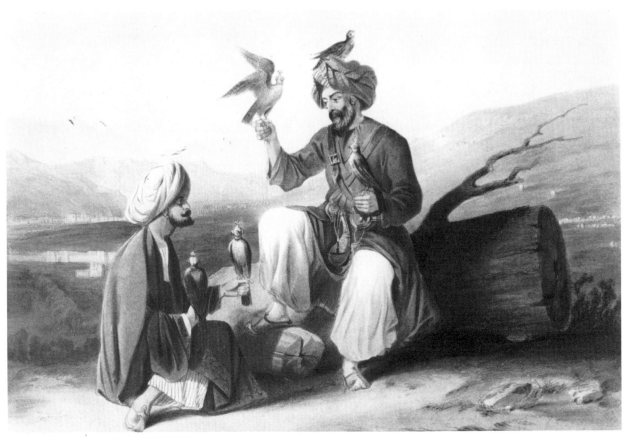

66 J. Rattray, *Hawkers of Ko-i-Staun*, cat. 82

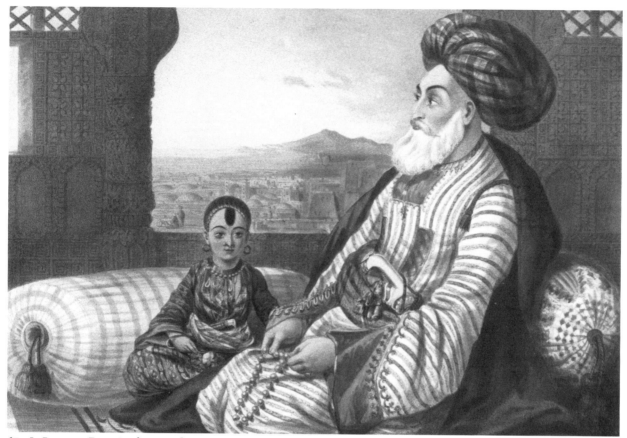

67 J. Rattray, *Dost Mohammed . . . and his Youngest Son*, cat. 81

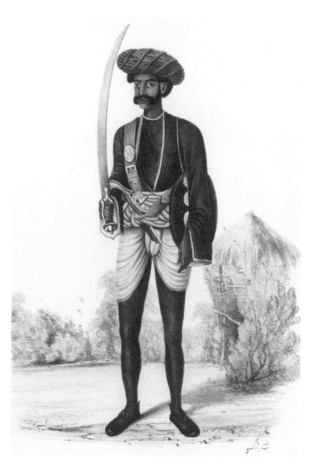

68 F. Parks, *A Barkandāz*, cat. 86

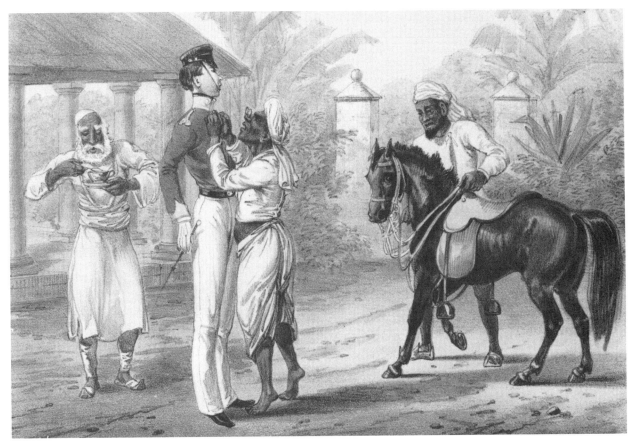

69 G. Atkinson, *Our Griff*, cat. 91

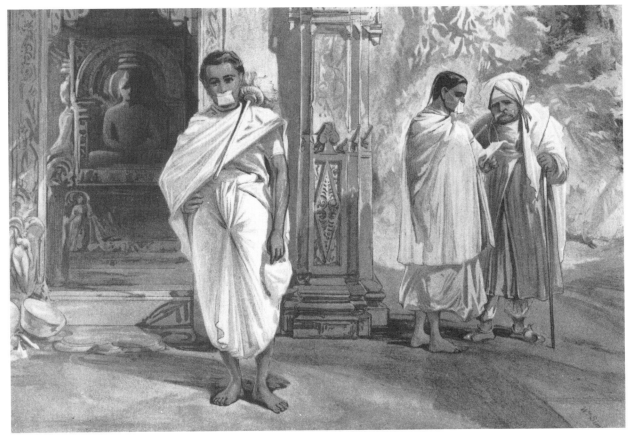

70 W. Simpson, *Jains*, cat. 92

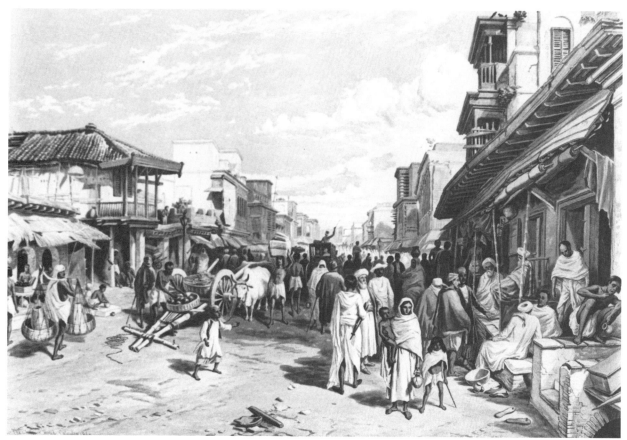

71 W. Simpson, *Chitpore Road, Calcutta*, cat. 93

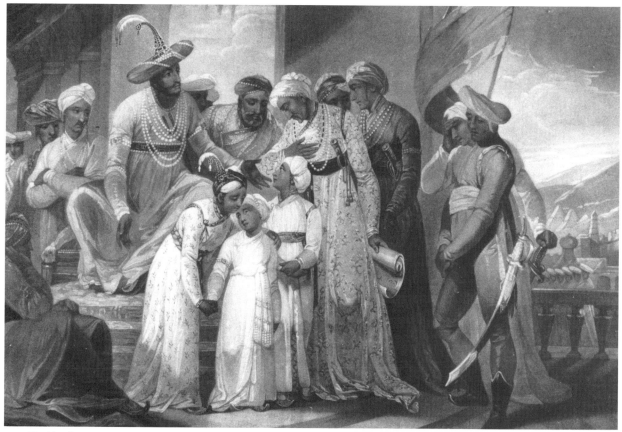

72 H. Singleton, *Sons of Tipu Sultan Leaving their Father*, cat. 95

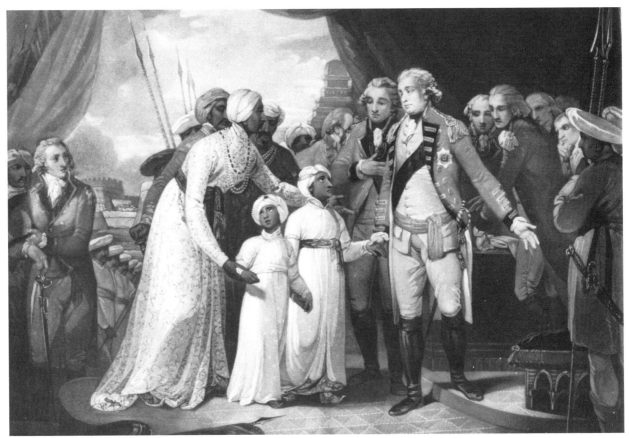

73 H. Singleton, *Lord Cornwallis Receiving the Sons of Tipu*, cat. 96

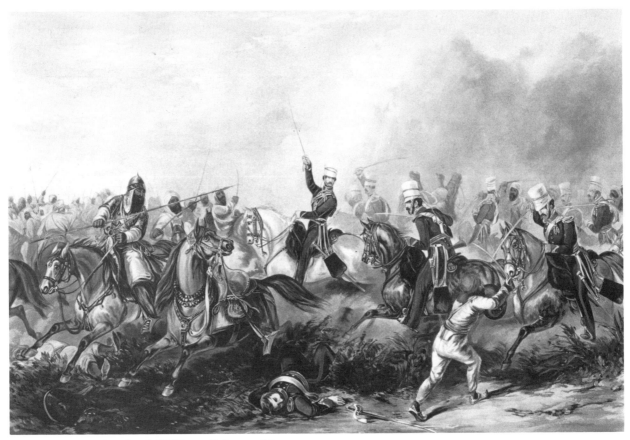

75 H. Martens, *Battle of Chillienwallah*, cat. 98

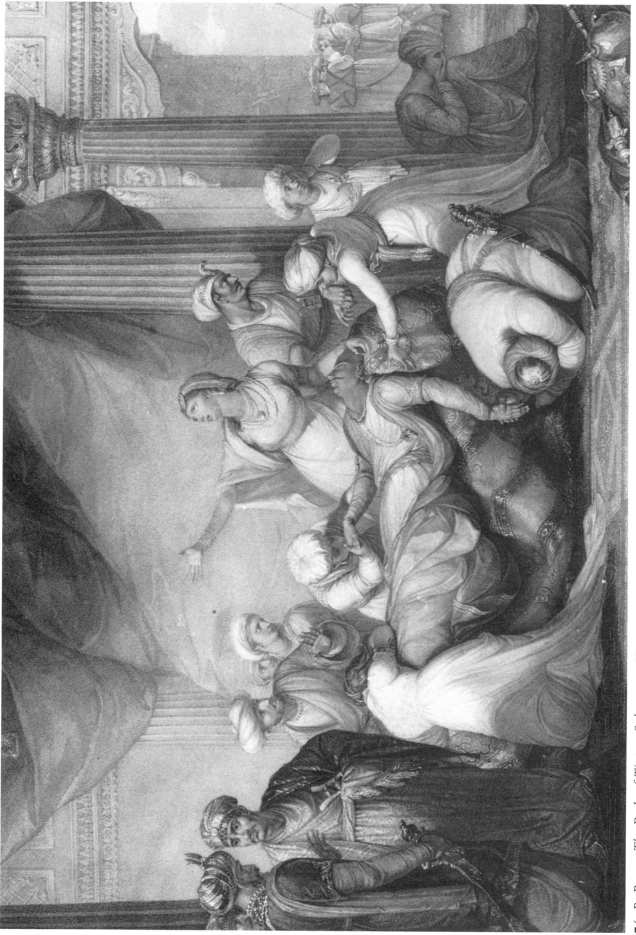

74 R. Porter, *The Body of Tippoo Sultan*, cat. 97

55

CATALOGUE

Although a complete artists' index to both essay and catalogue follows the catalogue, it will be helpful to know that the factor determining an artist's position in the catalogue is generally the year in which the artist's earliest print or book on India was published. For example, an artist whose first print in this exhibition is dated 1799 precedes one whose first print is from 1800. Within each entry for an artist, however, all the artist's works in this exhibition are included and arranged chronologically. A brief commentary on each artist and his or her work is followed by the principal bibliographic sources.

The catalogue entries are next. A catalogue number for a book indicates its presence in the exhibition. Catalogue entries are generally self-explanatory, but a few points require comment. The abbreviation 'JA' is a bibliographic citation to John Abbey's catalogue of illustrated travel literature (see abbreviations list below). The number immediately following 'JA' refers to Abbey's main entry for a particular book or portfolio, while numerals after the colon refer to his number for a specific illustration within the book or portfolio cited. Abbey should normally be considered part of an artist's bibliography.

Measurements are given in inches, height before width, and dates are those of initial publication and/or later reprint of the book or print. If the artist of a print is other than the author/artist on the title page of the book or portfolio being discussed, his name will be listed before the title of the print. For medium, only the principal technique is given. Aquatint, for example, is listed simply as such, although it is always accompanied by etching.

Finally, it should be remembered that, with one exception, all of the works in the exhibition are from the collection of Mr. Max Allen and Mr. Peter Allen.

The following abbreviations are frequently used:

DNB: *Dictionary of National Biography* (Oxford, 1885–1901; reprint 1921–22)

INOB: Archer, Mildred and Ronald Lightbown, *India Observed: India Viewed by British Artists 1760–1860*, exhib. cat., Victoria and Albert Museum (London, 1982)

IOL: Archer, Mildred, *British Drawings in the India Office Library*, 2 vols. (London, 1969)

JA: Abbey, John R., *Travel in Aquatint and Lithography 1770–1860*, II (London, 1957; reprinted 1972)

WAL: Foster, W., "British Artists in India," *The Volume of the Walpole Society*, XIX (Oxford, 1930–31), 1–88.

For fuller bibliographies on the artists and the subjects, see those in the IOL and INOB. One should also consult the Pierpont Morgan Library exhibition catalogue *From Merchants to Emperors: British Artists and India, 1757–1930* (New York, 1986). This catalogue touches on many of the artists who are included here, and the essays by Pratapaditya Pal and Vidya Dehejia are interesting for their content and their point of view. A study of this period from a literary point of view, also with an extensive bibliography, is the work by Ketaki Kushari Dyson, *A Various Universe: A Study of the Journals and Memoirs of British Men and Women in the Indian Subcontinent, 1765–1856* (New Delhi, Oxford Univ. Press, 1978).

WILLIAM HODGES (1744–1797)

William Hodges spent three brief years in India, from 1780 to 1783, but his vision of this picturesque country and his kaleidoscopic impression of its architecture gave birth to the great illustrated and colored portfolios of India in the late eighteenth century. Hodges' only peers were his contemporaries Thomas and William Daniell.

While the Daniells complained of the technical shortcomings of Hodges' *Select Views...*, which Hodges had etched and aquatinted himself, Hodges' use of aquatinting and hand coloring truly does suggest the effect of watercolor washes. Certainly his plates are no more amateurish than Thomas Daniell's plates in *Views of Calcutta*, and Hodges evinces at times, in a wispiness of style and an almost Rococo frothiness, a lightness of touch that the Daniells might have envied. Hodges' images are geographically more limited in scope and subject matter than the Daniells' but what the Daniells could not gainsay was Hodges' precedence in producing the earliest major illustrated folio on the subject that was to inspire so many more great works.

INOB, pp. 8–10, 74–80

IOL, II, p. 613

Stuebe, Isabel C., *The Life and Works of William Hodges* (New York, 1979)

WAL, 40–42

Select Views in India (London, 1786–88), JA 416

1 *A View of the Gate of the Caravan Serai, at Raje Mahel* (JA 416:4); hand-colored aquatint (11¼ × 17⅜), 1785 **fig. 20**

2 *A View of a Farm-Yard in the Kingdom of Bengal* (JA 416:16); hand-colored aquatint (11¼ × 17⅜), 1786 **fig. 19**

3 *A View of Tombs at Secundru near Agra* (JA 416:40); hand-colored aquatint (11¼ × 17⅜), 1788 **fig. 21**

THOMAS DANIELL (1749–1840)
WILLIAM DANIELL (1769–1837)

The work of Thomas Daniell and his nephew William is perhaps better known than that of any other artists who worked in India. Other than those of Hodges' work, which they sought to surpass, the images they painted and etched became the standard picture of the subcontinent for almost one hundred years. Their work spanned late eighteenth-century India from Cape Comorin in the South to the Himalayas in the North, and they recorded this world in detail and with enthusiasm.

The pair reached Calcutta in early 1786 and remained in India until 1794. While in India, Thomas Daniell published only one work, *Views in Calcutta* (1786–88), which clearly catered to a local pride in that emerging British city. The 12 plates were etched and minimally aquatinted by Thomas himself and then hand colored by local workers. Besides the very refined, detached, almost mannered style of drawing, particularly of the figures who languidly glide across the foreground, the coloring is understated, almost wholly transparent. The aquatinting is limited, much of the shading coming from the application of the washes. While not so technically polished as the Daniells' later work, *Views in Calcutta* has its own attractions, and it typifies the concern of these two artists with the monuments of native India and British India as opposed to anthropological or sociological interests.

Oriental Scenery appeared in six parts and 144 plates between 1795 and 1808. The plates, in completed sets of 24, with accompanying descriptive booklets, were all published after the Daniells' return to England, and technically they show Thomas's and especially William's growing mastery of the aquatint process. Outlines are etched, of course, but much is executed in pure aquatint, notably the skies and the foliage. The watercolor washes are very delicate, tending toward earth tones and blue, but never dense and opaque as in later work by other artists.

Except for views of the Presidency towns of Calcutta and Madras, the Daniells were interested mainly in Indian architecture and monuments, and not English architecture or the Indian landscape. Landscape does play a larger role in some of the late prints, but it still remains secondary. Interestingly, as much as the Daniells write in a romantic vein about the Indian landscape (e.g., the Falls at Puppanassum), their style and perception of this landscape as translated into drawing and etching is very precise, clean, "tea party-ish." Theirs is a very unpopulated, almost Arcadian vision of the country.

Not all the designs were drawn by Thomas or William. The 24 plates illustrating the excavated temples in the mountain of Ellora were done from the drawings of James Wales. That the Daniells were copying the work of Wales rather than their own drawings may explain certain stylistic differences between these etchings (JA 420:102–25) and the other plates. In particular, those after Wales have forms that are softer and outlines that are more organic and less rigid.

Between 1812 and 1816 a reduced quarto edition in six volumes, uncolored, was issued of *Oriental Scenery*, but neither Thomas nor William etched the plates.

Archer, Mildred, *Early Views of India: The Picturesque Journeys of Thomas and William Daniell 1786–1794* (London, 1980). See this work for a more complete bibliography on the Daniells.

INOB, pp. 10–11, 42–46, 48, 64–66, 120–21, 130, 143–44

IOL, pp. 574–99

WAL, 20–23

Views in Calcutta (Calcutta, T. Daniell, 1786–88), JA 492

4 *Part of the Old Tank* (JA 492:3); hand-colored etching (15⅛ × 20½), 1786 **fig. 1**

5 *The New Buildings at Chouringhee* (JA 492:7); hand-colored etching (15⅜ × 20⅛), 1787 **fig. 2**

6 *Calcutta from the River Hoogly; Gentoo Buildings* (JA 492:8); hand-colored etching (15⅝ × 20½), 1788 **fig. 3**

Oriental Scenery (London, 1795–1808), JA 420

7 *Gate of the Tomb of the Emperor Akbar, at Secundra, near Agra* (JA 420:10); hand-colored aquatint (17⅛ × 23⅝), 1795 — fig. 23

8 *Dusasumade Gaut, at Bernares* [sic], *on the Ganges* (JA 420:17); hand-colored aquatint (17 × 23½), 1796 — fig. 22

9 *View on the Chitpore Road, Calcutta* (JA 420:28); hand-colored aquatint (16⅝ × 23½), 1797 — fig. 4

10 *South East View of Fort St. George, Madras* (JA 420:33); hand-colored aquatint (16⅛ × 23⅜), 1797 — fig. 15

11 *Govinda Ram Mittee's Pagoda, Calcutta* (JA 420:31); hand-colored aquatint (16⅜ × 23¼), 1798 — frontispiece

12 *The Assembly Rooms on the Race Ground, near Madras* (JA 420:37); hand-colored aquatint (16⅝ × 23¼), 1798 — fig. 14

13 *View in the Fort of Tritchinopoly* (JA 420:47); hand-colored aquatint (16⅝ × 23¾), 1797 — fig. 24

14 *Sculptured Rocks, at Mavalipuram, on the Coast of Coromandel* (JA 420:52); hand-colored aquatint (16⅝ × 23½), 1799 — fig. 26

15 *The Entrance of an excavated Hindoo Temple, at Mavalipuram* (JA 420:53); hand-colored aquatint (16½ × 23½), 1799

16 *Part of the Interior of the Elephanta* (JA 420:59); hand-colored aquatint (16¾ × 23¾), 1800 — fig. 28

17 James Wales, *N. E. View of Kailâsa* (JA 420:115); hand-colored aquatint (16⅞ × 23¾), 1803 — fig. 29

18 *Cape Comorin, taken near Calcad* (JA 420:127); hand-colored aquatint (16½ × 23¼), 1804 — fig. 27

19 *The Water-Fall at Puppanassum in the Tinnevelly District* (JA 420:128); hand-colored aquatint (16½ × 23¼), 1804 — fig. 25

ROBERT H. COLEBROOKE (1762–1808)

Robert Colebrooke served in the Bengal Infantry between 1778 and 1808 as a surveyor and draftsman.

The portfolio of views that Colebrooke produced in 1794 of the Mysore district, scene of the early Mysore Wars between Tipu Sultan and the British, reflects both his training as a surveyor and British interest in the wars of this remote area. Most of the views have military significance and, like the accompanying text, are largely descriptive. Colebrooke did not etch the plates himself, and the engraver who did had a decidedly flat style, with broad, wavy outlines. The whole is sketchy but with a finely grained aquatint. The plates were re-published in 1804–05, and it is from this edition that the prints on exhibition come.

IOL, I, pp. 142–43

INOB, p. 47

Twelve Views of Places in the Kingdom of Mysore (London, E. Orme, 1805; first edition, 1794), JA 426

20 *N. W. View of Nandydroog* (JA 426:5); hand-colored aquatint (14⅜ × 20), 1804 reprint

21 *S. W. View of Ootra-Durgum* (JA 426:8); hand-colored aquatint (14½ × 19⅞), 1804 reprint — fig. 30

THOMAS ANBUREY (1759–1840)

Like Colebrooke, Thomas Anburey was an outstanding surveyor who served during the period of the Mysore Wars. Anburey's *Hindoostan Scenery*... is a 'tour' of sorts, but from a military point of view, "shewing the difficulty of a March thro' the Gundecotte Pass." Anburey did not etch his plates. Although they were produced by only one engraver, Francis Jukes, their quality varies.

INOB, pp. 61–62

Hindoostan Scenery consisting of Twelve Select Views in India Drawn on the Spot... (London, T. Anburey, 1799), not in Abbey

22 *View within the Northern Entrance of Gundecotta Pass* (not in Abbey); hand-colored aquatint (14 × 20⅝), 1799 — fig. 31

FRANÇOIS BALTHAZAR SOLVYNS (1760–1824)

A native of Antwerp and husband of an Englishwoman, François Solvyns came to India in 1790, and between the years 1795 and 1799 he produced a true monument to native life in Bengal. His ...*Manners, Customs and Dresses of the Hindoos* is comprised of 250 plates that he etched and hand colored, and for which he provided a brief descriptive text. The plates, with additions, subtractions, and revisions, appeared in several editions, three of which are exhibited here.

The first edition of 1799 was printed in Calcutta, purportedly on paper Solvyns had made in India. His etching is technically and stylistically crude, and he handles the needle in a squiggly, unsure fashion. The coloring is thin and at times almost washed out. But the work shows such a cumulative energy, as the pages are turned, that these shortcomings become altogether minor. The figures have an immediacy that only an observant person could give them, and Solvyns imparts a sympathetic and monumental aspect to each subject by making it dominate the background and the full page. The 1799 plates have a greater sense of visual reality than the abbreviated and redrawn images of the 1804–05 edition of 60 plates. Solvyns rightly disowned the 1804–05 edition, published by Edward Orme. In the latter only single figures are represented, and these are by comparison simpler, antiseptic, and vigorless. Solvyns himself undertook another enlarged edition between 1808 and 1812, which he entitled *Les Hindoûs* and published in Paris. The etching is far more practiced and professional than in his 1799 edition, and the coloring is better controlled. Solvyns redrew many of his 1799 plates, but he included fewer supplementary details and reversed the originals.

Solvyns died in 1824, having dissipated his wife's fortune to publish his works. He received little reward, either financial or laudatory.

Archer, Mildred, "Baltazard Solvyns and the Indian Picturesque," *The Connoisseur* (Jan. 1969), 12–18.

INOB, pp. 68, 83–84

23 **A Collection of Two Hundred and Fifty Coloured Etchings: Descriptive of the Manners, Customs and Dresses of the Hindoos**, 2 vols. (Calcutta, Balt. Solvyns, 1799), JA 421

24 **The Costume of Hindoostan** (London, Edw. Orme, 1804–5), JA 429

Les Hindoûs (Paris, B. Solvyns and H. Nicolle, 1808–12), JA 430

25 *Femme de Distinction* (JA 430:80); hand-colored etching (13½ × 9⅜), 1810 **fig. 55**

26 *Houka à tuyau* (JA 430:206); hand-colored etching (13¼ × 9⅛), 1811 **fig. 56**

FRANCIS WILLIAM BLAGDON (1778–1819)

JAMES HUNTER (died 1792)

FRANCIS SWAIN WARD (c. 1734–1794)

WILLIAM DANIELL (1769–1837)

In 1805 Edward Orme published three works that are separate publications but are generally thought of together. These are the *Picturesque Scenery in the Kingdom of Mysore* of James Hunter in 40 plates; the *24 Views in Hindostan* after paintings by William Daniell and Francis Swain Ward; and *A Brief History of Ancient and Modern India* by Francis William Blagdon (1778–1819). Collectively the three works are catalogued under Blagdon and are so treated here.

Francis William Blagdon was an author, translator, and editor of considerable energy, whose works were largely either political or religious polemics but included literary and travel subjects as well. Orme surely commissioned Blagdon to write this essay—filling only twenty-two horizontal pages—to complement the two portfolios of plates. Abbey has already pointed out this likelihood, as well as that Orme was prepared to sell either Hunter or Ward separately with Blagdon's text. Blagdon's text itself was reprinted in 1813 in Charles D'Oyly's *The European in India*.

Hunter, who had served from 1790 to 1792 during the Third Mysore War, died in India in the latter year.

His watercolors of southern India were worked up by Orme in ten parts between 1802 and 1805. Again, British interest in the scenery of the long-standing Mysore Wars, which had recently ended, probably accounted for Orme's publishing these drawings.

The third volume, the *24 Views*, was etched after paintings by William Daniell and Francis Swain Ward that had been in the collection of a former mayor of Madras. Ward was both artist and military man, serving in the army briefly in the early 1760s, resigning for a career in painting in 1764, and then re-enlisting in 1773. He spent most of his time in Madras, but on at least two occasions he did travel north. As an artist he seemed to be held in fairly high esteem by the East India Company.

Both the *Picturesque Scenery* and the *24 Views* vary considerably in the quality of their drawing. The least satisfactory work was done by the engravers Fellows and Sadelar, while Merke's etching is consistently the best. Merke etched and aquatinted the three plates exhibited here.

Francis William Blagdon:
DNB, XXII (1st supp.), pp. 211–12

James Hunter:
INOB, pp. 49, 67

IOL, I, pp. 231–32

Francis Swain Ward:
INOB, pp. 33–34

IOL, II, pp. 640–42

William Daniell:
see his entry

A Brief History of Ancient and Modern India (London, Edw. Orme, 1805; reprint 1813), JA 424

27 William Daniell, *Thebet Mountains* (**24 Views in Hindostan**), JA 424:12; hand-colored aquatint (11⅛ × 16⅜), 1804

28 Francis S. Ward, *A View of part of St. Thomé Street, Fort St. George* (**24 Views in Hindostan**), JA 424:13; hand-colored aquatint (11⅞ × 16¾), 1804 **fig. 16**

29 James Hunter, *Hyder Ally Khan's own Family Tomb, at Colar* (**Picturesque Scenery in the Kingdom of Mysore**), JA 424:31; hand-colored aquatint (9½ × 12½), 1804 **fig. 32**

THOMAS WILLIAMSON (1758–1817)

Presumably because of his critical views of East India Company military and personnel policies, Thomas Williamson was ordered out of India in 1798 after twenty years in the Bengal European Regiment. Subsequently he wrote and/or illustrated several works on India. He was, in fact, rather prolific on this subject, as well as on the more general topics of fishing and surveying. It was Williamson who provided the preface and descriptions to Charles D'Oyly's *The European in India*.

Oriental Field Sports was a work of 40 colored aquatints based on Williamson's drawings, with his accompanying text. Williamson's drawings had been worked up for the etchers by Samuel Howitt. The practice of having a professional artist prepare the drawings of an amateur for the etcher was not uncommon and is true for many of the works in this exhibition. Artists like Solvyns or the Daniells did their own preparatory drawings, as well as etch their own plates, but they are exceptions.

Oriental Field Sports proved popular enough to warrant several editions in different formats by 1819, and there was even an 1892 reproduction of selected parts.

INOB, p. 67

Oriental Field Sports (London, Edw. Orme, 1805–07), JA 427

30 *The Ganges breaking its Banks, with Fishing, etc.,* (JA 427:14); hand-colored aquatint (12¼ × 17⅛), 1805 **fig. 13**

31 *A Tiger prowling through a Village* (JA 427:25); hand-colored aquatint (12⅜ × 17), 1806 **fig. 37**

32 *Decoy Elephants leaving the Male fastened to a Tree* (JA 427:10); hand-colored aquatint (12½ × 17⅜), 1807

CHARLES GOLD (died 1842)

Stationed on the southeastern or Coromandel coast of India, Captain Charles Gold made a virtue of necessity and concentrated his studies on the subjects at hand. His principal interests were in the religious and social life of the Indians and the caste system by which they lived. Gold's comments are learned for the day, and at

times humorous. He cannot help but remark that the "Gentoo Zealot," a Hindu whose religious pilgrimage between two temples one hundred miles apart was accomplished entirely by rolling on the ground, was "a man of property [who] had two servants clearing the way of refuse and what ever as well as providing him with refreshments."

Oriental Drawings... has 49 plates, each with descriptive text of varying length. While one can appreciate and enjoy Gold's choice of subjects and his rendering of them, their execution by professionals suffers from a lack of technical subtlety.

INOB, p. 85

Oriental Drawings: sketched between the Years 1791 and 1798 (London, G. & W. Nicoll, 1806), JA 428

33 *A Gentoo Zealot* (JA 428:4); hand-colored aquatint (10⅛ × 8⅜ [sight]), 1800 — **fig. 57**

34 *Gentoo Women* (JA 428:21); hand-colored aquatint (11¼ × 9 [sight]), c.1800 — **fig. 58**

HENRY SALT (1780–1827)

Henry Salt's *Twenty-four Views*..., a work whose subject goes beyond the boundaries of India, grew out of his association as secretary to George Annesley, Viscount Valentia, during the latter's travels in the East. Salt himself was both an artist and something of an antiquarian, publishing in addition to the *Twenty-four Views* books on hieroglyphs, Egyptian archaeology, and the west coast of Africa. Salt's publisher, William Miller, saw *Twenty-four Views* as a continuation in size and format of the Daniells' *Oriental Scenery*, and probably as a pendant to Valentia's *Voyages and Travels to India, Ceylon, The Red Sea, Abyssinia, and Egypt, in the Years 1802...1806* (London, 1809). Other drawings by Salt, however, were engraved specifically for inclusion in Valentia's book.

Salt's drawings were translated into aquatints under Robert Havell. Like those of James Baillie Fraser ten years later, Salt's views are characterized by sunset-colored skies and figures highlighted with saturated colors, particularly red and blue. Otherwise the color scheme is much like that of the Daniells.

INOB, pp. 50–51, 67–68

IOL, II, pp. 627–32

Twenty-four Views in St. Helena, The Cape, India, Ceylon, The Red Sea, Abyssinia, and Egypt (London, W. Miller, 1809), JA 515

35 *A View at Lucknow* (JA 515:6); hand-colored aquatint (16¼ × 23½), 1809 — **fig. 33**

36 *Mosque at Lucknow* (JA 515:7); hand-colored aquatint (16¾ × 24½), 1809 — **fig. 34**

37 *Pagoda at Ramisseram* (JA 515:10); hand-colored aquatint (16½ × 24), 1809 — **fig. 35**

38 *Pagoda at Tanjore* (JA 515:11); hand-colored aquatint (16½ × 23⅜), 1809 — **fig. 36**

CHARLES D'OYLY (1781–1845)

Charles D'Oyly had a successful career in the East India Company from 1798 to 1838, living at various times in Calcutta, Dacca, and Patna. Well-educated and intelligent, D'Oyly was also artistically gifted and, as a leading amateur artist, he energetically exploited his abilities. Although he drew and painted throughout his life, the publication of his work falls into only two periods: 1813–16 and 1828–30. The one exception, *Views of Calcutta*, appeared posthumously in 1848.

The earlier period is dominated by etching and aquatint illustration, while the later period is almost exclusively devoted to lithography. In the late 1820s D'Oyly imported a lithographic press from London for his own use, and afterward he undertook much lithographic work himself. He trained an Indian artist, Jairam Das, in the intricacies of lithographic printing, and he occasionally collaborated with other artists, as with Christopher W. Smith on ornithological illustrations. He dubbed his "publishing house" the Behar Lithographic Press, and from it he issued his variously titled "Behar Lithographic Scrapbooks." The scrapbooks were compilations of his and others' lithographs, but seemingly without any specific plan or order. The scrapbooks were apparently all published between 1828 and 1830.

D'Oyly's style of lithographic drawing is rather stiff, with simple figures. While he seems to have published the lithographs uncolored, their neutral gray tonality and grainy texture were suited to subsequent coloring. Altogether, what these lithographs lack in facility they make up for as energetic, personal sketches of Indian life and the land.

Several of D'Oyly's other works were etched or lithographed by professionals. *The European in India* (1813, reprinted as *The Costume and Customs of Modern India*, c. 1824), *Antiquities of Dacca* (1816)

and *Views of Calcutta* (1848) were such works, but these publications were the product of London publishing houses and not solely of D'Oyly's doing.

Archer, Mildred, "'The talented baronet': Sir Charles D'Oyly and his drawings of India," *The Connoisseur* (Nov. 1970), 173–80.

INOB, pp. 70–72, 91, 96, 140, 154

IOL, I, pp. 162–69

The Costume and Customs of Modern India (London, Edw. Orme, c.1824), JA 435/440

39 *A Gentleman in a public Office, attended by his Crannies, or Native Clerks* (JA 435/440:3); hand-colored aquatint (4¾ × 3⅞), c.1824?

40 *An European Lady attended by a Servant, using a Hand Punkah, or Fan* (JA 435/440:16); hand-colored aquatint (4¾ × 3⅞), c.1824? **fig. 59**

41 *Nuts or Indian Jugglers* (**Behar Amateur Lithographic Scrap Book?**); hand-colored lithograph (6½ × 5⅜), 1828–30? **fig. 60**

42 *A Potter's Shop* (**Behar Amateur Lithographic Scrap Book?**); hand-colored lithograph (6½ × 5⅜), 1828–30? **fig. 61**

Views of Calcutta (London, Dickinson & Co., 1848), JA 497

43 *East Gate – Government House* (JA 497:1); hand-colored lithotint (21¼ × 15), 1848 **fig. 10**

44 *Mosque at Borranypore* (JA 497:9); hand-colored lithotint (11¾ × 16⅜), 1848 **fig. 11**

45 *Suspension Bridge at Alipore over Tolly's Nulla* (JA 497:20); hand-colored lithotint (11⅞ × 16⅜), 1848 **fig. 12**

46 *Hindoo Temple near the Strand Road* (JA 497:25); hand-colored lithotint (11¼ × 16⅜), 1848

JAMES BAILLIE FRASER (1783–1856)

James Baillie Fraser's *Views in the Himala Mountains* and his *Views of Calcutta and its Environs* rank with the best prints done on India. His work is compositionally and stylistically excellent, and technically his drawings have been well served by the copiest and printer. The coloring in both is dense and the whites are painted on. Like Henry Salt, Fraser had a penchant for bright red and blue clothing on his figures, which isolates them from the earth tones otherwise used. And like Salt, he favored the moment of twilight, with pinkish skies enhancing the drama of the setting. Fraser's works also have a very strong human presence, which is lacking, for example, in images by the Daniells, Salt, or Forrest. With Fraser the human element of a D'Oyly or Gold and the scenic sense of a Thomas Anburey or William Daniell become better integrated. With the advent of works like Fraser's the tendency to look simultaneously at both the physical and human components of the Indian world seems more marked.

DNB, VII, pp. 651–52

INOB, pp. 100–02

Views in the Himala Mountains (London, Rodwell & Martin, 1820), JA 498

47 *Seran Rajas Palace* (JA 498:2); hand-colored aquatint (16⅛ × 23½), 1820

48 *Assemblage of Hillmen* (JA 498:13); hand-colored aquatint (16⅛ × 23½), 1820 **fig. 41**

Views of Calcutta and its Environs (London, Rodwell & Martin, 1824; Smith Elder & Co., 1825–26), JA 494

49 *A View of Chandpal Ghat* (JA 494:1); hand-colored aquatint (10⅞ × 16⅜), 1824 **fig. 5**

50 *A View of the Botanic Garden House and Reach* (JA 494:4); hand-colored aquatint (10⅞ × 16⅞), 1824 **fig. 6**

51 *A View of the Scotch Church, from the Gate of Tank Square* (JA 494:12); hand-colored aquatint (11 × 16¾), 1825 **fig. 7**

52 *View of St. John's Cathedral* (JA 494:19); hand-colored aquatint (10¾ × 16¾), 1826 **fig. 8**

53 *A View of the Black Pagoda, on the Chitpore Road* (JA 494:23); hand-colored aquatint (10⅞ × 16¾), 1826 **fig. 9**

CHARLES RAMUS FORREST (active 1802–1827)

Charles Forrest did military service in India from 1802 until 1826. He died the year after his retirement.

Unlike most of the works discussed so far, Forrest's *Picturesque Tour...* is an illustrated book rather than a portfolio of views with brief descriptive texts. Forrest devotes more than half of it to his history of India; the remainder describes his tour and includes illustrations after his drawings. The drawings are well done, but their coloring varies from light and delicate to heavy and opaque. The discrepancies in coloring seem typical for the period. Denser and more opaque applications of color had begun to supplant the thinner, more translucent watercolor washes of the eighteenth century. As the comparatively small size of Forrest's *Picturesque Tour* suggests, the book is meant to be held and read, but by the high quality of its illustrations it remains very much in the tradition of the great view books.

INOB, pp. 53, 86, 102

54 **A Picturesque Tour Along the Rivers Ganges and Jumna, in India** (London, R. Ackermann, 1824), JA 441

55 *Sacred Tank and Pagodas near Benares* (JA 441:14); hand-colored aquatint (8 × 10⅞), 1824 **fig. 38**

56 *Mahomedan Mosque and Tomb, near Benares* (JA 441:15); hand-colored aquatint (7⅞ × 10⅝), 1824 **fig. 39**

57 *The Taj Mahal, Tomb of the Emperor Shah Jehan and his Queen* (JA 441:24); hand-colored aquatint (8 × 10¾), 1824 **fig. 40**

ROBERT M. GRINDLAY (1786–1877)

Robert Grindlay served in the Bombay Native Infantry from 1804 to 1820, and after retirement he set up his own import-export firm. The images in his *Scenery, Costumes and Architecture...*, the two volumes of which were published in 1826 and 1830, probably have more immediate appeal than do most prints of this era. They epitomize a romantic view of India that is sensual, mysterious, and captivating. The illustrations that Grindlay used were not all by his own hand but included those of several professional and amateur artists like William Westall and John Johnson. It has been noted that exceptional care was taken in the execution of the aquatinted and etched plates for this book, and in their hand coloring. Abbey, however, also points out that the book underwent more than one printing. These subsequent printings affected the quality of later impressions, and their coloring clearly was more summarily applied. In the best impressions,

however, the book compares well with the finest illustrated works of the first half of the century.

John Johnson (c.1769–1846) was, like Grindlay, a military man, having served in the Bombay Engineers from 1785 to 1817. In 1818 he published *A Journey from India to England*, with his own drawings. He returned to England in 1819.

William Westall (1781–1850) was a professional artist who spent from early 1804 to early 1805 in Bombay. He painted views of the Mahratta Mountains and of the cave temples of Karlee and Elephanta. He returned to England in 1805 and later did topographical work for publishers like Ackermann, or Rodwell and Martin. He exhibited his Indian views at the Royal Academy in 1817, 1824, and 1828.

Robert Grindlay:

INOB, pp. 89–90, 140

IOL, I, pp. 233–35

For later, steel engraved reproductions of Grindlay's plates, see:

Basil Hunnisett, "Steel Engraved Scenes from India," *Antiquarian Book Monthly Review* (July, 1986), 256–61

John Johnson:

IOL, I, pp. 233–35

William Westall:

DNB, XXI, pp. 1259–61

INOB, pp. 51–52, 140

58 **Scenery, Costumes and Architecture, Chiefly On the Western Side of India**, 2 vols. (vol I: London, R. Ackermann, 1826; vol. II: London, Smith, Elder & Co., 1830), JA 442.

59 William Westall, *Approach of the Monsoon, Bombay Harbour* (JA 442:3); hand-colored aquatint (8 × 11⅛), 1826 **fig. 44**

60 William Westall? *Mountains of Aboo in Guzerat, with the source of the River Suruswuttee* (JA 442:7); hand-colored aquatint (8⅜ × 11⅛), 1826 **fig. 45**

61 *Great excavated Temple at Ellora* (JA 442:13); hand-colored aquatint (8⅞ × 11½), 1826 **fig. 46**

62 *Preparation for a Suttee, or the Immolation of a Hindoo Widow* (JA 442:14); hand-colored aquatint (8⅞ × 11¼), 1830 **fig. 47**

63 John Johnson, *Fishing Boats in the Monsoon, Northern part of Bombay Harbour* (JA 442:23); hand-colored aquatint (7¾ × 11), 1830 — fig. 48

64 *View of the Bridge near Baroda in Guzerat* (JA 442:24); hand-colored aquatint (8½ × 11½), 1830 — fig. 49

65 *Scene in Kattiawar, Travellers and Escort* (JA 442:28); hand-colored aquatint (7½ × 11⅛), 1830

66 *Aurungabad, From the Ruins of Aurungzebe's Palace* (JA 442:30); hand-colored aquatint (9 × 11⅞), 1830 — fig. 50

67 William Westall, *Entrance of the Great Cave Temple of Elephanta, near Bombay* (JA 442:31); hand-colored aquatint (8 × 11⅛), 1830 — fig. 51

68 *View of Sassoor in the Deccan* (JA 442:33); hand-colored aquatint (9⅛ × 11⅞), 1830 — fig. 52

69 *The Sacred Town and Temples of Dwarka* (JA 442:34); hand-colored aquatint (8⅞ × 11⅛), 1830

70 *Portico of a Hindoo Temple with other Hindoo and Mahomedan Buildings* (JA 442:38); hand-colored aquatint (11⅞ × 8¾), 1830 — fig. 43

JOHN LUARD (1790–1875)

A much-decorated professional military man as well as an amateur artist, John Luard was first posted to India in 1822, where "during a residence of eight years in India...[he]...filled a portfolio with interesting sketches of the country and its inhabitants, from Calcutta to the Himalayah Mountains." Luard's *Views in India...*, from which the quotation above is taken, is a fascinating, detailed work, covering an exceptionally broad range of subjects, and, for all the scenic views, there are equally as many illustrations of the people and their lives. Luard was a more than competent draftsman. As for his illustrations, he wrote that "the enormous expense of line engraving...induced him to draw them himself upon stone." The plates as published are uncolored and printed on a grayish, thin, laid-down paper. The book does not bear an imprint but parts appeared between 1833 and 1837.

DNB, XII, pp. 226–67

INOB, pp. 142–43

Views in India, Saint Helena and Car Nicobar (London, c.1833–37), not in Abbey

71 *Itinerant Snake Catchers* (not in Abbey); hand-colored lithograph (5¾ × 9), c.1835 — fig. 62

RICHARD BARRON (active 1815–1838)

The Nilgiri Hills that Richard Barron describes and illustrates lie in the Western Ghat, a range of mountains paralleling the west coast of southern India. Barron was stationed there in 1835. His illustrations and Robert Havell's aquatinting of them are of uniformly high quality. Barron's views are almost all of British residences in this area. The exception is the print of the Toda family that is exhibited here.

INOB, pp. 147–48

Views in India, Chiefly Among the Neelgherry Hills, taken during a short residence on them in 1835 (London, Robert Havell, 1837), JA 459

72 *Taken at Kandelmund, Which it Represents, and the Toda Family Inhabiting* (JA 459:6); hand-colored aquatint (15⅛ × 20⅜ [sight]), 1837 — fig. 63

J. B. EAST (active 1837)

Nothing has yet come to light about the life of J. B. East or these prints. Obviously the publisher Ackermann produced them as pendants, and he probably meant them to be framed and hung. Nothing suggests they were ever part of a larger portfolio.

It should be mentioned that Madras was without a natural harbor, so that landing or embarking was uniquely difficult.

73 *Madras Landing* (not in Abbey); hand-colored aquatint (14½ × 19⅞), 1837 — fig. 17

74 *Madras Embarking* (not in Abbey); hand-colored aquatint (14½ × 20⅛), 1837 — fig. 18

MARIANNE POSTANS (active 1837–1857)

The lithographic illustrations done from Marianne Postans' drawings for her volume on Cutch show both good drawing and good coloring.

Her husband Thomas Postans came to India in 1829 and remained there with the Bombay Native Infantry until his death in 1846. Both Marianne and Thomas had a scholarly interest in India, and Marianne also published *Facts and Fictions Illustrative of Oriental Character* (1844). She remarried after Thomas's death.

INOB, p. 148

IOL, I, pp. 278–79

75 **Cutch, or Random Sketches of Western India** (London, Smith Elder & Co., 1839), not in Abbey
Durbar Horseman (not in Abbey); colored lithograph (8¾ × 5⅜), 1838

WILLIAM TAYLER (1808–1892)

William Tayler, a man of liberal views, served in the East India Civil Service for thirty years, beginning in 1829. By 1859 he had risen to be Commissioner of Patna. He resigned his post that year in the wake of the 1857 Sepoy Mutiny but remained in Bengal practicing law until 1867, when he returned to England.

His *Sketches...* is a thin folio volume of six lithographed and colored plates with descriptive text. That these prints satirize the British is clear when plates are paired by the viewer: an English couple at breakfast and a group of Sunyasees ascetics; an Englishman's toilet and an image of the village barber; an English-woman's toilet and Indian women grinding grain. Tayler's biographer in the DNB noted that "his official career had been uneventful, though he made friends in high quarters by his skills as a portrait-painter, and some enemies by a turn for caricature."

DNB, XIX, pp. 400–02

76 **Sketches Illustrating the Manners & Customs of the Indians & Anglo Indians Drawn on the Stone from the Original Drawings from Life** (London, T. McLean, 1842), JA 465

The Young Civilians [sic] *Toilet* (JA 465:1); colored lithograph (10⅞ × 8½), 1842 fig. 64

EMILY EDEN (1797–1869)

Emily Eden's *Portraits...* is a compilation in four parts of 24 plates. Lithographed after her watercolors by Lowes Dickinson, whose firm also published the plates, they appeared in both colored and uncolored editions. The work follows a standard format of image with descriptive text. Besides this gallery of portraits, Emily Eden's correspondence from India to her sister was published in 1866 as *Up the Country* and subsequently reprinted in several editions. As the sister of Lord Auckland, Governor-General of India, Emily Eden had easy access to the courts of the native rulers of India.

DNB, VI, p. 356

INOB, pp. 151–52

IOL, I, p. 184

77 **Portraits of the Princes & People of India** (London, J. Dickinson & Son, 1844), not in Abbey
78 *Raja Heera Singh* (not in Abbey); hand-colored lithograph (14½ × 9⅜), 1844
79 *Late Maha Raja Runjeet Singh* (not in Abbey); hand-colored lithograph (13⅛ × 9⅝), 1844 fig. 65

CHARLES STEWART HARDINGE (1822–1894)

Charles Hardinge was in India from 1844 to 1848 and fought in the first Sikh war. After the treaty of 1846 he journeyed through Kashmir and the North, drawing and painting as he went. His drawings were lithographed for the most part by J. D. Harding, and portfolios were published both colored and uncolored.

IOL, I, pp. 222–23

Recollections of India (London, T. McLean, 1847), JA 472

80 *Kashmir, Bij Beara* (JA 472:21); colored lithotint (10⅞ × 14⅜), 1847 fig. 53

JAMES RATTRAY (died 1855)

Very little is known of James Rattray other than that his years of active military service were from 1839 to 1855.* His drawings of Afghanistan, however, and the accompanying descriptions comprise one of the finest volumes of the period on the lands in the northwest. In both his writings and in his imagery, Rattray seems a particularly sympathetic observer of the peoples and places he saw. His reaction to the plight of the deposed ruler Dost Mohammed seems genuinely felt, and his text suggests that Rattray could speak the ruler's language.

Rattray was well served by Day and Son, the lithographers who printed the 30 brilliantly hand-colored plates of *Scenery, Inhabitants & Costumes. . . .* Their subject matter intermixes scenes of military life with closely observed images of the natives and of the surrounding scenery and life. The large folio is visually one of the most arresting from this period.

*These dates were kindly provided by Mildred Archer.

Scenery, Inhabitants, & Costumes, of Afghaunistan from Drawings made on the Spot (London, Hering & Remington, 1848), JA 513

81 *Dost Mohammed King of Caubul and his Youngest Son* (JA 513:2); hand-colored lithotint (11⅞ × 12⅝), 1847–48 fig. 67
82 *Hawkers of Ko-i-Staun. With Valley of Caubul and Mountains of Hindoocoosh* (JA 513:4); hand-colored lithograph (10½ × 14¾), 1847–48 fig. 66

CHARLES RICHARD FRANCIS (active 1848–1895)

Charles Francis, as he tells us on the title page of *Sketches of Native Life*. . .(1848) was a medical doctor, and the dates of his medical publications suggest that he had an extended if not lifelong stay in India. His last dated work in the British Museum Library catalogue is an *Anglo-Urdu Medical Handbook* of 1895. *Sketches* is the earliest work, and of most interest for its portrayal of daily life.

83 **Sketches of Native Life in India, with Views in Rajpootana, Simlah, etc., etc.** (London, 1848), not in Abbey
 A Moonshee (not in Abbey); hand-colored lithograph (8⅞ × 10⅜), 1848

FANNY PARKS (1794–1875)

Fanny Parks' two-volume, quarto-sized narrative of her twenty-four years in India, from 1822 to 1845, was published in 1850. The text is the book's most important contribution, but the 49 lithographed plates are interesting, although they vary in quality. The illustrations are a mix of plates printed as lithotints, plates printed with a black stone only, and plates that are hand colored. The images are also from a variety of sources, including Indian miniatures, and not solely from Fanny Parks' sketches. As something of an affectation, Fanny Parks wrote her name throughout the book in Urdu, the *lingua franca* of British India. The language was a mix of Persian and Hindu, with a Persian alphabet.

INOB, pp. 129, 154

84 **Wanderings of a Pilgrim, in Search of the Picturesque, During Four-and-Twenty Years in the East; with Revelations of Life in the Zenana,** 2 vols. (London, Pelham Richardson, 1850), JA 476
85 *A Bengalee Woman* (JA 476:8); hand-colored lithograph (8⅛ × 6⅝), 1850
86 *A Barkandāz* (JA 476:15); colored lithograph (8¾ × 6⅝), 1850 fig. 68

MRS. W. L. L. SCOTT (active 1852)

Nothing is known about Mrs. Scott except for her *Views in the Himalayas*. She produced this to aid the Lawrence Asylum, near Simla, for orphaned children of soldiers serving in India. An odd coincidence to note, if it is that, is the appearance in 1850 of a small oblong folio of lithotints entitled *Simla Scenes*, drawn on the

stone by an A. E. Scott.* Perhaps he was Mrs. Scott's spouse or a relation. In any case, the 14 lithotints by Mrs. Scott have an extraordinarily uniform aspect topographically, texturally, and tonally. Every view looks like every other, a fault that may not be entirely hers, but partially that of the lithographers.

*Not in Abbey; the copy consulted is at the Yale Center for British Art, Yale University.

Views in the Himalayas (London, Henry Graves & Co., 1852), JA 500

87 *Simla, the North Face of Jukko, the Bank in 1850, the Craigs, (Sir Henry Elliott's Residence), Captn Mayow's House, etc. etc.— Sunrise* (JA 500:7); colored lithotint (12¼ × 19½), 1852 **fig. 42**

CHARLES HENRY MEECHAM
(active 1858)

Charles Meecham's *Sketches & Incidents. . .* (1858) is typical of a genre of literature and illustration that is essentially reportage on military operations abroad. Like Colebrooke's *Twelve Views*, it concerns itself with military events of great significance to the British. Meecham, who was stationed in Madras, made the original drawings of the siege of Lucknow during the Sepoy Mutiny of 1857. His drawings are technically and compositionally excellent, and he has been well handled by his lithographers. The plates are lithotints with a light beige ground, and they vary from a full page rectangular format to oval vignettes, two to a page.

88 **Sketches & Incidents of the Siege of Lucknow. From Drawings made during the Siege** (London, Day & Son, 1858), not in Abbey

The Baillie Guard Battery and Hospital (not in Abbey); lithotint (9½ × 14⅛), 1858

GEORGE F. ATKINSON (1822–1859)

Atkinson, who served in the Bengal engineers from 1840 to 1859, published in 1859 *Curry & Rice*, his satiric account of life in a remote Indian outpost at mid-century. Composed of 40 vignettes, each of which Atkinson illustrated with a lithograph, the book explores the various levels of Station society. Atkinson's gentle barbs about Anglo-Indian life proved especially popular, for three editions appeared in 1860, a fourth in 1911, and a reprint in 1982. The original plates were lithotints, as in the first edition exhibited here, while the two individual plates exhibited were only subsequently hand colored.

IOL, I, pp. 95–96

89 **Curry & Rice (on Forty Plates) or The Ingredients of Social Life at "Our" Station in India** (London, Day & Son, [1859]), JA 487.
Lent by Special Collections, Homer Babbidge Library, The University of Connecticut.

90 *Our Doctor* (JA 487:13); hand-colored lithotint (6 × 8½), 1859

91 *Our Griff* (JA 487:21); hand-colored lithotint (6⅛ × 8½), 1859 **fig. 69**

WILLIAM SIMPSON (1823–1899)

In 1859, William Simpson, a well-known illustrator and painter, was commissioned by Day and Son to produce a series of drawings of India. The result was *India, Ancient and Modern*. While Simpson was a very accomplished draftsman and watercolorist, his work was undermined by the coloring of contemporary chromolithography. Chromolithography, which had begun in 1837, had matured technically by the 1860s and was appealing to the broad audience that publishers wanted. It meant the end of the aquatinted or lithographed book that was hand colored. India more than ever was to become the common property of the English through mass reproduction by chromolithography and, later, by photography.

Archer, Mildred, *Visions of India: The Sketchbooks of William Simpson 1859–62* (Topsfield, MA, 1986)

IOL, II, pp. 635–36

India, Ancient and Modern (London, Day & Son, 1867), not in Abbey

HISTORICAL PRINTS

The following prints form a kind of addendum to the others in this exhibition. They are historical prints in the sense that they treat specific occurrences and are specifically narrative rather than descriptive. These characteristics set them apart from the prints previously discussed. The mezzotints, for example, after the paintings of Henry Singleton (1766–1839) or Robert Ker Porter (1777–1842) depict events surrounding the reign of Tipu Sultan, ruler of the southern kingdom of Mysore and implacable enemy of the British during the Mysore Wars. Historical accuracy was not an issue in these, however, since what counted foremost was how the artist's interpretation manipulated one's emotional reaction to the event. Porter's imagery, for example, explicitly associates the discovery of Tipu Sultan's dead body with a traditional lamentation over the body of Christ. By suggesting that the two scenes are parallel statements, the importance of Tipu to his reverent subjects is underlined, and as a consequence the British defeat of him and his forces is enhanced. The issue, however, is clouded by the sentiment of the scene, a factor even more apparent in Singleton's paintings of Tipu's sons being taken hostage. With such presentations, one cannot help but feel sorry for the enemy! No such ambivalence exists in the straightforward group portrait by John Zoffany (1733–1810), but the battle scene of Henry Martens (died 1860) suggests not the actual defeat of the British at Chillienwalla but a heroic battle.

Of course, all of the prints in this exhibition manipulate our perception of India and Indian history. They were meant to. But through much of this period the artists had a very positive, inquiring attitude toward the country and the people. By and large the British themselves and not the Indians were the object of British satire and derision. The Sikh Wars and the Sepoy Mutiny of 1857, however, were watershed events in Anglo-Indian history, and altered Indian and British affairs finally and forever. The implicit rule of the British became an explicit fact; the implicit economic subjugation of India became the explicit colonialism of the British. A finite and definable period of history had come to an end.

INDEX TO ARTISTS